11/85

Edward Weston in Mexico
1923-1926

Amy Conger Foreword by Van Deren Coke

Edward Weston in Mexico
1923–1926

Schmitt

The San Francisco Museum of Modern Art, May 6–July 1, 1983
The Albuquerque Museum, Albuquerque, NM
The Amon Carter Museum, Fort Worth, Texas
The Minneapolis Institute of Arts, Minneapolis, Minnesota
California Museum of Photography, University of California, Riverside
The Museum of Fine Arts, St. Petersburg, Florida
The Center for Creative Photography, Tucson, Arizona

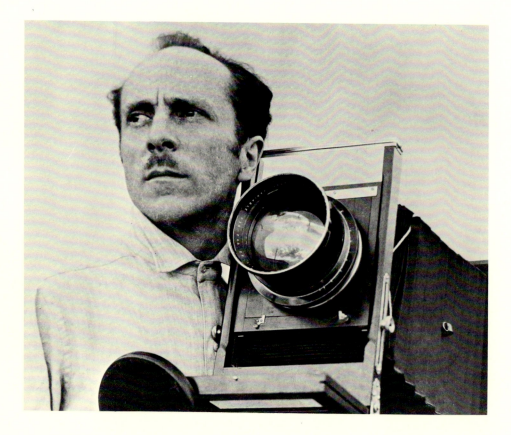

Tina Modotti (?), *Edward Weston with his 8 by 10 inch Seneca View Camera with a Graf Variable Lens*, Mexico, ca. 1924. Courtesy of the Amon Carter Museum, Fort Worth, Texas.

Edward Weston in Mexico
1923-1926

Amy Conger

Foreword by Van Deren Coke

Published for the San Francisco Museum of Modern Art
by the University of New Mexico Press Albuquerque

Library of Congress Cataloging in Publication Data

Conger, Amy, 1942–
 Edward Weston in Mexico, 1923–1926.

 Based on thesis (doctoral)
 Published on the occasion of an exhibition at the
San Francisco Museum of Modern Art, May 6–July 1, 1983,
and others.
 Checklist of photographs in the exhibition: p.
 Bibliography: p.
 Includes index.
 1. Photography, Artistic—Exhibitions. 2. Mexico—
Description and travel—Views. 3. Weston, Edward, 1886–
1958. I. Weston, Edward, 1886–1958. II. San Francisco
Museum of Modern Art. III. Title.
TR647.W44 1983 779'.9972 83-5877
ISBN 0-8263-0665-9
ISBN 0-8263-0666-7 (pbk.)

Contents

Illustrations vii

Foreword, by Van Deren Coke ix

Preface xv

1 Mexico: August 1923–December 1924 3

2 California: January 1925–August 1925 37

3 Mexico: August 1925–December 1926 41

In Retrospect 71

Abbreviations Used in the Notes and Bibliography 77

Notes 79

Selected List of References 93

Introduction to the Checklist of Photographs in the Exhibition 99

Checklist of Photographs in the Exhibition 103

Illustrations

Maps

Central Mexico 6
Mexico City and Vicinity 1925 12

Plates

1 *"The Great White Cloud of Mazatlán,"* 1923 9
2 *"Juguetes Mexicanos": "Ragdoll and Sombrerito,"* 1925 27
3 *"Circus Tent,"* 1924 33
4 *"Calle Mayor"* or *"Pissing Indian," Tepotzotlán,* 1924 35
5 *"Anita," Nude Back, II,* 1925 45
6 *"Tree and Petate, Pátzcuaro,"* 1926 57
7 *"Hand of Amado Galván,"* 1926 59
8 *"Casa de Vecindad," II,* 1926 63
9 *"Hat and Shoes,"* 1926 67
10 *Woman Seated on a Petate,* 1926 75

Figures

frontispiece Tina Modotti (?), *Edward Weston with his 8 by 10 inch Seneca View
 Camera with a Graf Variable Lens, Mexico,* ca. 1924 ii
1 *"Tina Modotti Reciting Poetry," II,* 1924 5
2 Pablo Picasso, *The Watering Place,* 1905 13
3 *Elisa Guerrero,* 1923 14
4 *Monna Alfau, Laughing,* 1924 15

5 *"Rafael Sala," Seated, 1924* 15

6 *"Jean Charlot," 1926* 16

7 *"Caballito de Cuarenta Centavos"* or *"Horsie," 1924* 16

8 Cover of *Irradiador,* no. 3, 1924 with *"Smokestacks," 1922* 18

9 *"Diego Rivera," Smiling, 1924* 20

10 Unknown Photographer, *Edward Weston Seated in Front of the Pulquería "La Gloria en Triunfo," 1926 (?)* 25

11 *Matador and Arena (Pulquería), 1926* 25

12 *Petate Woman in Front of an Aztec Chair, 1926* 28

13 *"Mexican Toys": Bull, Pig, Horse, and Plate, 1925* 28

14 *"Three Fish—Gourds," 1926* 29

15 *Manuel Hernández "Galván—Shooting," 1924* 29

16 Unknown Photographer, *Felipe Teixidor, Tina Modotti, Pepe, Manuel Hernández Galván, Edward Weston, Monna Alfau, and Rafael Sala in the Countryside, 1924* 30

17 *"Nahui Olín," 1923* 30

18 *"Pirámide del Sol," Teotihuacán, 1923* 31

19 *Cirrus and Cumulus Clouds, 1924* 31

20 *Tina Modotti, Half-Nude in Kimono, 1924* 34

21 *"Tronco de Palma," 1925* 39

22 *"Pájaro Blanco," 1926* 42

23 *"White Heron," 1926* 42

24 *"Excusado" from Above, 1925* 43

25 *"Tres Ollas de Oaxaca," 1926* 44

26 *"Charrito" (Pulquería), 1926* 46

27 *Two Children in Front of a Landscape (Pulquería), 1926* 46

28 *"Clay Bells" from Oaxaca, 1926* 52

29 *"Arcos, Oaxaca," 1926* 53

30 *"Heaped Black Ollas" in the Oaxaca Market, 1926* 54

31 Hugo Brehme, *"Lake Pátzcuaro, Xanicho Island"* 56

32 *"Janitzio, Lake Pátzcuaro," 1926* 56

33 *"Wheat Heart," 1926* 58

34 *"Maguey, Texcoco," without Clouds, 1926* 62

35 Unknown Photographer, *Tina Modotti, Rafael Sala, Edward Weston, Monna Alfau, and Felipe Teixidor in Front of a Maguey Plant, 1926 (?)* 62

Foreword

I first met Edward Weston in the Carmel Highlands in the summer of 1938. He generously took hours to show this then teenager a broad selection of his prints. I was especially impressed by those done in Mexico. As a consequence, he introduced me to his collection of Mexican folk art objects, many of which had been subjects for pictures made when he lived in Mexico in the mid 1920s. Both his pictures and the humble artifacts fascinated me then and continue to do so today.

I was very pleased when Amy Conger agreed to write an essay about the work Weston did in Mexico and to help prepare the exhibition for which this book is a catalogue. Her essay is based on her pioneering doctoral dissertation in which she has identified over 900 Weston photographs done before 1927, a remarkable job of scholarly sleuthing for which we will all be grateful in the future.

Why did Weston go to Mexico when he was thirty-seven years old? In answer, I, like Dr. Conger at the beginning of her essay, turn to Weston's letters to Stieglitz. Weston wrote in 1922, "I leave for Mexico to start life anew, why I hardly know. . . ." It now is plain that Weston left the Los Angeles area to propitiate the demons of boredom with his very conventional wife, to carry on his love affair with Tina Modotti, and to undertake a process of photo-purification. He was eager for new directions and had a driving inner need to see different subjects and find fresh inspirations. Margrethe Mather and Johan

Hagemeyer had been instrumental in 1919–20 in introducing him to new ideas about form, both in music and the pictorial arts. In other ways his awareness of modern art and cubism had also increased significantly by 1920. He had a copy of Arthur Jerome Eddy's 1914 book *Cubists and Post Impressionism* and probably saw at Los Angeles's Museum of History, Science and Art, in February 1920, the exhibition of paintings by American modernists that included work by Oscar Bluemner, Konrad Cramer, Andrew Dasburg, Arthur Dove, Morgan Russell, Charles Sheeler, Joseph Stella, and S. MacDonald Wright. All of these artists were using various aspects of cubism in their paintings. Inspired by Eddy's book and by the paintings of such artists as these American modernists, he took cubistic pictures in 1920 in Ramiel McGehee's slant-walled attic room in Redondo Beach, California. These were followed by even more geometric pictures, among them his 1922 picture of Johan Hagemeyer's head and shoulder, illuminated by a polygon of bright light that met a dark geometric shape in the center of his composition, and his photograph of the top of Ruth Shaw's head, into which a flat, white diagonal slices to repeat a similar shape created by the cut of her bobbed hair. Such cubistic or more clearly constructivist characteristics as sparity and precision of form were soon absorbed by Weston, but we can see the influence of geometry and tilted planes in dozens of the pictures done in Mexico.

The work he did in Mexico for himself—art, that is, as opposed to commissioned work—was certainly formal in character, but there was also an almost mesmerizing sense of fantasy about it, despite the fact that it is clearly defined and quite straightforward in appearance. Weston's already fine command of photographic techniques and his eye for visual eloquence kept him from being bewildered by what he found in Mexico. The concepts that always governed his vision came from an awareness of cubism, and from seeing examples of modern art such as the sculpture of Brancusi reproduced in his well-thumbed copies of the *Little Review*. Even so, the enchantment of Mexico took a firm grip on him. By osmosis he absorbed and made telling pictorial use of the material properties of Mexican walls and the popular arts used to adorn them. He turned the seductive light of Mexico into an agency that separated and abstracted masses, just as had the ancient Indian sculptors and architects.

In landscapes especially it was ever a battle to make out of the raw reality a photograph that was not romantic or picturesque. On all sides was the physical

immediacy of cloud-dappled hills, framed naturally by evergreens, under which
serape-clad Indians walked beside heavily laden burros. While true to the
country, such subjects had been photographed so often that they were clichés,
and Weston avoided them.

Weston's intent was to provide new means for better understanding of the
beauty and mystery of the Mexican landscape, eschewing the formulas used by
previous photographers. While in some respects his pictures were lyrical, there
was always an emphasis on the structural aspects of nature, whether spiked
maguey plants or fluffy cumulus clouds. His landscapes often unite man's
monuments and the natural terrain in such a way as to make us see them as
stemming from the same sources. In using this approach Weston refined for
us the undiscriminating experience of looking at the world around us. While his
viewpoints were carefully calculated, there is something very elusive about his
landscapes. The formal arrangements of the elements and the meticulous sharp-
ness of the details do not add up to fully informative images. Like much of his
work after 1923, they are a blend of realism and abstraction. We are captivated
by the sense of enigma he could evoke by inventorying parts which he then
juxtaposed with strategically placed odd passages that speak of the mystery we
feel before a darkened niche or cave opening. His picture of the island village of
Janitzio on Lake Pátzcuaro is a striking example of this kind of combination. The
eerie, transient light reflected on the lake's surface combines with the angular,
cubic buildings, so ambiguous as to scale and details, to convey a sense of the
ageless serenity one experiences often in Mexico.

The nudes Weston did in Mexico were only marginally different from
those he had done in the last two years he was in Glendale. One of Tina
unabashedly showed her pubic hair, something that would have truly raised
eyebrows in the United States but was thought to be perfectly natural in the
circles Weston moved in in Mexico. Those of Anita Brenner's back were perhaps
more abstract in sculptural terms than earlier examples, that is, they more
readily recall Brancusi in their hermetic simplicity. The most interesting pictures
that could be related to Brancusi, however, were the pictures of the basin of
Weston's toilet. In his daybook he wrote that the form of this vessel was classic
and related to antique Greek art. In a more contemporary vein, he was able to
impart to the molded shape of the lustrous bowl, by concentrating our attention

on its swelling characteristics, a sense of Brancusi's greatly simplified forms. The "hip-shot" base and the feeling of very smooth geometry appeared later in the pictures of shells, fruits, and vegetables that he did soon after returning to the United States from Mexico.

Weston was in Mexico during the revolutionary period (1911–27) when Indians were being assimilated into the life of the nation. There was great interest in the work of village potters, artisans who worked in papier-mâché, and weavers of straw figures. Toys made of these materials were produced for sale just before religious holidays such as Christmas, Easter, and the Day of the Dead, so that the artisans would have money for celebrating during the fiesta. Some of the ritual clay objects have roots in Precolumbian times; others are of Christian origin. An especial interest in these folk art objects was taken by the government during the period Weston was in Mexico. Sales to tourists provided money for the Indians, but these crafts were further seen as indigenous manifestations of village artistic traditions unencumbered by European or academic aims. They were considered examples of the innate ability and imagination of the native people of Mexico.

Weston's still-life studies of handicrafts are alive with dancing patterns. Yet each figure is treated with respect. By placing the little toys against backgrounds that are neutral or quite different in character, he concentrates attention on the craft as well as on the forms, regardless of function. Embodied in his pictures are clues to the cultural role of each toy. Singled out by point of view are the characteristics that best define each piece or exemplify the subtle influences that reside in them.

The toys, woven materials, and wood objects give us an idea of the Indians' unending patience and convey the wisdom and aesthetic concerns that these people, then as now, brought to the everyday practice of life. The real subject of his Mexican pictures of the clay and straw toys was the life vibrations, the philosophical attitudes he felt when handling and looking at these simple objects. The photographs of such objects launched him on a path of exploration of still life that marked a radical break with the past. It would culminate in his magnificent pictures of fruits and in his work of the period 1927–33.

Weston's portraits, which usually crowd the frame and gain strength thereby, are like emphatic punctuation marks in any narrative history of Mexico in the turbulent 1920s. They vibrate with life: the beautiful Rose Covarrubias,

wife of an internationally recognized artist; the explosive Senator Galván, soon to be assassinated; heavy-jowled Rivera in his peaked hat; his wife, the strikingly alive, dark-haired Guadalupe Marín de Rivera and perhaps one of the greatest portraits of them all, that of Nahui Olín, the tempestuous Mexican girl raised in Paris who was the mistress of the famous Dr. Atl. All were important in the new intellectual society prevailing in Mexico City. Pictorially, Weston made the most of their beautiful, distinctive heads while conveying his subjects' personalities. His photographs monumentalized these personalities, and spoke eloquently of a new consciousness of Mexico's great potential as well as of the photographer's keen insights and skills with the camera.

I did not know any of the people Weston photographed in Mexico, except through his powerful portraits. I have, however, traveled over much of the parts of Mexico that he saw in the years 1923–26 and therefore have some understanding of what he achieved. To have resisted working with the exotic aspects of the place, the flowers, fog in the mountains, or Indian children showed great restraint on his part. The moody feeling of incipient violence is also missing. What he did pin down were the ever-changing patterns of light and dark, the layers of meaning present in old thick walls, and the spirit of nature that is so palpable in Mexico. As a collector of Mexican figurative folk art I have a special fondness for the little toys and other hand-crafted objects he loved and photographed. He had a sharp eye for details and for what they could tell us about the use and origins of a piece, however small it might be. Faithfully represented, and yet in Weston's own style, was the haunting history of each object. He made it easy for us to feel the mystery as well as the mundane side of the life of those who shaped the little forms in clay, straw, or paper.

In my six or seven visits with him from 1938 to almost the end of his life, we talked about Mexico, for I was then often vacationing there. He was well aware of the importance of his years in Mexico and often recalled the heightened sense of nature he experienced there, the sheer wonders of the landscape, and the warmth of the beautiful people. His period in Mexico completed his liberation from the lure of pictorial photography, the salons, and their fancy awards for sentimental pictures—awards that had brought him great satisfaction before 1920. The venture upon which he embarked in Mexico was vibrant with life and optimism. The role of art in the society in which he found himself in Mexico City

was quite different from what he had known in bustling, commercial Los Angeles. Exhibitions of his photographs in Mexico resulted in rave reviews, and he sold his prints as works of art. However, he gradually felt, he must return to his homeland and see his boys and the friends he missed. Echoes of what he had achieved in Mexico continued to resound in his work for a decade, and perhaps they never truly died out. As Nancy Newhall insightfully noted, Mexico was for Weston what Paris was for so many other American artists.

Van Deren Coke, Director
Department of Photography
San Francisco Museum of Modern Art
© 1983

Preface

For many people today Edward Weston (1886–1958) and his work are a vital part of our national heritage and our public cultural domain. A. D. Coleman summarized the extent of Weston's influence and following articulately: ". . . it is my belief that he will eventually be seen as an awesome, monumental boulder in the path of the evolution of photography in the twentieth century."[1]

Considering this kind of veneration, I was particularly surprised by two discoveries that came out of my study on the early work of Weston (1903–26). The first was that no more than half a dozen vintage prints of any one of Weston's best known works from 1923 through 1926 have survived. This means that most viewers' knowledge and appreciation of Weston's work is based on reproductions of photographs, not on the photographs themselves. These two categories of pictures are mistakenly and unfortunately too often equated. Weston was a photographer, not a printmaker or a photolithographer, and illustrations of photographs may be the most deceptive of all reproductions in art history: they manage to copy the image and the colors, but the glowing tonalities and subtle textures of the originals are almost always sacrificed. In some ways, the differences are as significant as the differences between Greek sculpture and Roman copies of Greek sculpture. In the case of Weston's work, however, many prints by him do exist, and they deserve to be known.

The second surprise was the realization of how little is known about the first half of Weston's career in view of the esteem in which he was held for most

of his life and in which he is held today. Weston was active as a photographer for forty-five years, between 1903 and 1948. Although the three years from 1923 through 1926 are basically the chronological and stylistic transition between two periods, only about forty photographs made by him at this time have been reproduced over and over again, although I located more than 600.

The criteria used to select photographs for this exhibition were the intrinsic and sustaining aesthetic interest of the works and, of course, their availability. Less well known or virtually unknown photographs were often selected for reproduction in order to expand the public's awareness of Weston's accomplishments and approach since the total number of reproductions of photographs by Weston which could be included in this catalogue was limited to forty by the Weston Estate. Reproductions of classic photographs by him can be found in the standard monographs included in the Selected List of References.

Just as it is not advisable to base a critical opinion of Weston's work on only a few reproductions, it is not fair to him as a man or as a photographer to interpret his *Daybooks* as if they were appointment books or industrial production records. Although he recorded some sittings, trips, prices, parties, problems, and relationships in them, and it is largely on the basis of the *Daybooks* that it has been possible to reconstruct a narrative account of his stay in Mexico, these are diaries which he kept and shared with his friends, and in which, in the heat of the moment, he described the events that made each day distinct. At times, they seem to have been a substitute for a punching bag; Weston apparently tried to direct his disappointments at the *Daybooks* rather than at those around him. He noted in them: "but write I must, no matter to what end. It is the safety valve I need in this day when pistols and poisons are taboo." [2] He also questioned the validity of his own observations:

> I am doubting more and more the sincerity of these daily or semi-weekly notes as they concern me personally—my real viewpoint and feelings uncolored by petty reactions, momentary moods. With the passing of time, perhaps the greater part of what I write would not be thought worth writing, either forgotten entirely, or realized as untrue.
>
> I am sure, nevertheless, that my diary is a safety valve for releasing corked-up passions which might otherwise explode—though I sometimes think storm clouds would sooner break with a

thunder of words,—but a perspective of months might bring a saner,
less hysterical, more genuine outlook.[3]

The *Daybooks* were edited by Nancy Newhall to eliminate redundancy and to assure that certain opinions would not be misunderstood out of context, that no one would be embarrassed, and that Weston would not feel like a "pretentious prig."[4] He was not obsessed or compelled by the ways others might judge him, although he sometimes apologized for his behavior and opinions. As he set his own standards for photographic excellence, he also set his own standards for feelings and conduct. As a result, we probably know more about Weston's artistic personality than we do about any other photographer's. As a historian, I feel considerable gratitude to him and admiration for him since he was relatively un-self-conscious about sharing all this material with those who followed. His candor, combined with his willingness to accept his own past, reflects the vital qualities and a straightforwardness of his photography.

Fortunately for us, in the 1930s and 1940s Charis Wilson and Nancy Newhall independently realized that they were involved with a major artist. Both of them dedicated astounding energy to recording and remembering the man, his creative process, and what he had accomplished.

Throughout this study Charis Wilson has been extremely generous with her recollections and her patience—often making it possible to bring together pictures and titles that otherwise probably never would have been reunited; recalling, for example, which was the photograph of Pátzcuaro he kept in his active portfolio; which was the portrait he called "Elisa"; remembering who Euripedes was (a cat); and even walking around San Francisco to determine from exactly what point he took a certain shot of rooftops that a librarian had labeled "Mexico City."

Charis is now working on a biography of Weston during the time she knew him and lived with him. I hope that she obtains the support she needs to complete this study since it will undoubtedly be both a reliable and an entertaining account of one of the great photographic personalities of our time.

Nancy Newhall (1908–74) had planned to write a biography of Weston, and he appointed her as his biographer. On one occasion, she commented: "All I seem to do is help it get born."[5] She asked him all the right questions and

accumulated several manila files full of notes—all of which Beaumont Newhall magnanimously opened to me for my study of the early work of Weston, as well as allowing me to edit and organize all their personal correspondence with him. It was Beaumont too who originally encouraged me to work on the topic for my dissertation. Since then, he has constantly kept an eye out for new material and followed each development and "discovery" enthusiastically. Certainly his continual interest, encouragement, and collaboration have demonstrated a magnanimity no one should expect. From reading all the material in Beaumont's library, I also realized that the extent of the generosity and support given by the Newhalls, Ansel Adams, David McAlpin, and Richard McGraw to Edward when he needed it in the last years of his life will never be fully known.

Weston's four sons have also contributed notably to this study, displaying some of their father's patience and generosity by tolerating hours of picky questions and looking at scores of images to see what they recalled about them specifically. Chandler often remembered the circumstances of photographs made sixty years ago; occasionally I was later able to verify his recollections. Neil and Brett both answered as many of my inquiries as they could, and Cole graciously allowed me to peruse those of his father's papers that were available before they passed to the Center for Creative Photography in Tucson in 1981.

Both James L. Enyeart, director of the Center for Creative Photography, and Terence R. Pitts, curator and librarian of the photographic archives there, have been extremely cooperative in making materials available to me and allowing me to use them in my work, and I am very grateful to them. I also recall with pleasure how enjoyable it has been to work with John Szarkowski and Susan Kismaric of the Photography Department of the Museum of Modern Art, Russ Anderson and Lisa Cremin of the Weston Gallery, and the staffs of the Bancroft Library of the University of California, Berkeley, the Collection of American Literature at the Beinecke Rare Book and Manuscript Library of Yale University, and the Jean Charlot Collection in Honolulu. Jean Charlot's widow, Zohmah, has contributed substantially to this study, not only loaning prints for the show, but also sending me lists of photographs by Weston in the collection and letting my brother Jim copy them.

I was able to go through materials in the Anita Brenner Collection where I located letters Weston wrote to her and unknown photographs by him; also, I

was allowed to make copies of them and notes from the journal she kept during this period; her entries often included valuable details as well as interesting observations. I am grateful to her Estate for having shared this material with me.

In Mexico I spoke to several people who had known Weston when he was there. Many of them remembered him fondly and clearly. It was an unforgettable pleasure for me to listen to them reminisce about that period, and to show them reproductions of prints by him and have them tell me about the works. These people are listed individually in the bibliographical section under "Interviews and Conversations."

Monna Alfau has been of particular importance. She was close to Weston—they attended the same parties and went on outings together—and he respected her taste, often asking her opinion about his latest prints. In addition, she has a very fine memory. On my first trip to Mexico, I was informed that her second husband, Felipe Teixidor, had died only a few days before. I was, of course, not sure I should get in touch with her or whether she would see me. When I went to her house to leave a letter, she had me shown right in. Since then I have spent many pleasant and stimulating hours with her; I understand why Weston was so fond of her. He surrounded himself with people who are not only interesting and enjoyable, but also worthy of great respect.

I would like personally to thank all the curators, collectors, and dealers who have spent time with me, helped me locate previously unknown prints, and consented to loan works for this exhibition. Van Deren Coke, Director of the Photography Department of the San Francisco Museum of Modern Art, former director of the Art Museum at the University of New Mexico, and founder of the university's photography collection and program, has taken an active interest in this study because of both his admiration for Weston and his work and his fascination with Mexican folk art. He has also arranged for the loan of the works in the exhibition and checklist and made this show possible. I am grateful for his continual help and collaboration and for that of Peter Bunnell, Paul M. Hertzmann, and Ben Maddow, who have shared their prints, papers, and ideas with me.

Other institutions and individuals have also contributed generously to the formation and completion of this work: Kurt Kubie, who is responsible for the Beaumont Newhall Fellowship; the Tinker Foundation of America; the Univer-

sity of New Mexico Graduate Student Association; the University of New Mexico Libraries, especially the Interlibrary Loan Department; Elizabeth C. Hadas, editor, and Barbara Jellow, designer, of the University of New Mexico Press who have made this catalogue a reality in the face of always new and original obstacles; Jean McVoy Sarabia and James Greenwood Conger, my parents; Antonio R. Sarabia, Jr., and James Conger, Jr., my brothers; my friends Joy and Bill Lucas, Nancy and David Eselius, Ivonne Szasz Pianta, Josephine Pianta, and Gustavo Maureira Farina; and P. K. Shepherd.

I would like to apologize if occasionally this essay appears to be part of a larger work; it is. The entire study is an analysis and incomplete catalogue of Weston's development from his earliest photographs, made in 1903 (of midwestern landscape), and the last prints so far located that he made in Mexico in late 1926 (studies of a tenement house). The complete monograph, which should fill in some of the gaps in this essay, may be published and made available for the centennial of Weston's birth in 1986.

Edward Weston in Mexico
1923–1926

ONE

Mexico
August 1923–December 1924

After having postponed his departure for Mexico at least four times within six months, at the end of May 1923 Edward Weston wrote to Alfred Stieglitz, the photographer he respected most, and mentioned that he had posted in his workroom a notice for himself which read: "I am a Liar." He confessed, "The acknowledgement satisfies my ego—I get perverse joy in this mental lashing— admitting to myself that after all I *know* better!"[1] Weston meant by this that the portrait work he was doing to support his family was not aesthetically enriching for him; it did not satisfy his desire or need to express himself through photography. He had begun taking snapshots in 1902, and by 1916 he had become a highly respected pictorial photographer. An issue of *Camera* magazine had been virtually dedicated to his work; he had been invited to do demonstrations at the Photographers' Association of America convention; his work was hung year after year in the prestigious Wanamaker exhibitions; he had accumulated scores of honors at salons; and finally, in 1917, he was elected one of six members of the London Salon of Photography from the United States—the only one from the West Coast.[2] He had mastered the pictorial aesthetic, but by 1920 he had practically stopped submitting photographs to salons. He tried to dedicate more of himself to his own work, which combined a modern vision with a fairly conventional pictorial technique. His photographs show familiarity with radical developments in the other visual arts and, as a result, were not appreciated by the pictorial establishment or by many other people. The aesthetic double

3

standard he was living, coupled with the traditional ambitions of those who loved him and the inevitable doubts of a creative person who sees a chance to turn off a well-traveled road, threatened the integrity of his artistic personality.

In the fall of 1922 Weston went to New York City. There he met the photographers Gertrude Käsebier, Clarence White, Charles Sheeler, Paul Strand, Nikolas Muray, and Alfred Stieglitz, who, on one occasion, was accompanied by the painter Georgia O'Keeffe. He also became acquainted with the art critic Herbert J. Seligmann and the editor of the magazine *Photo Miniature*, John Tennant.[3] This trip seems to have been the most stimulating experience of Weston's career up to that time. His traveling, until then, had consisted of local vacation trips during his childhood, his move from Chicago to California in 1906, trips back to the Midwest in 1915 and 1916, and extended weekends in San Francisco. His desire to travel had obviously been sacrificed to his domestic responsibilities.

Although the trip to New York does not seem to have influenced his work from a stylistic point of view, it certainly strengthened the direction in which he was already heading.[4] Part of his excitement was due to the people he met, and about two-thirds of the notes he made describe them,[5] but, as his notes also indicate, a considerable portion of his enthusiasm was evoked by the social and physical geography and the cultural offerings of New York City itself. A similar pattern emerges during Weston's stay in Mexico from 1923 until 1926.

Although in 1921 he had met and photographed the prominent Mexican art critic and Precolumbianist Ricardo Gómez Robelo, who would become director of the Mexican Department of Fine Arts later that year, Weston probably only seriously considered moving from Tropico, near Los Angeles, to Mexico City when he learned of the success there of the exhibition of his photographs at the Academia de Bellas Artes in the spring of 1922. He mentioned it in a letter to his friend the photographer Johan Hagemeyer: "Tina [Modotti] wrote me the exhibit a great success in Mexico—'already *many* of your prints have been sold'—'A prophet is not without honor', etc.—I think I have sold two prints in the many years I've exhibited in U.S."[6]

Years later, Weston summarized the frustration he had felt when confronted with the desire to move to Mexico:

A long period of personal conflict was required before I finally decided to break away and leave my family for Mexico. To the outer world I was a deserter, but I was not. If I had remained under conditions which could not have been, and never will be changed, I would have mentally poisoned all around me; destroyed them, my work, myself.[7]

However, in a letter written toward the end of 1922, Weston mentioned that he would leave for Mexico in March 1923 with Tina, who was his friend and lover, and Chandler, his eldest son. In late March, however, he informed Hagemeyer that the expedition would leave in about a month; by May 28, the date had been changed to June 21, "the Gods willing and the winds and tides propitious——."[8]

On July 12 Weston was still in California. He wrote to Stieglitz:

What you say re "pulling up roots" is true—it is ghastly for me!
To reconcile a certain side of one's life to another—to accept a situation without at the same time destroying another—to coordinate desires which pull first this way—then that—to know or try to know what is best for those one has brought into the world—and even knowing—to be able to do that "best" without destroying one's self—looms as an almost hopeless problem—and makes one wonder the "why" of this whole made [*sic*] life. . . .
. . . It almost seems at times I must be cruel—or else give up my own desires—for there are those whom one has loved—still love—and though they stimulate—they also drag—hold back—involve—destroy a certain singleness of purpose—clutter up the background—barricade the foreground—until I wonder if I am a weakling because I stand it or for the same reason very strong![9]

Finally, after he had postponed his trip to Mexico so many times that "the proposed adventure seemed but a conceit of the imagination, never actually to materialize," Rose Krasnow, a neighbor and friend, drove the entire Weston family and Tina to the ship on July 29. From the deck of the S.S. *Colima*, Edward, Tina, and Chandler looked back to the dock where the three youngest boys waved sadly, and Flora, his wife, called out: "Tina, take good care of my boys!"[10]

After a week at sea, when the ship was anchored in the Mexican port of

Figure 1 *"Tina Modotti Reciting Poetry," II.* 1924. Courtesy of the Weston Gallery, Carmel, California.

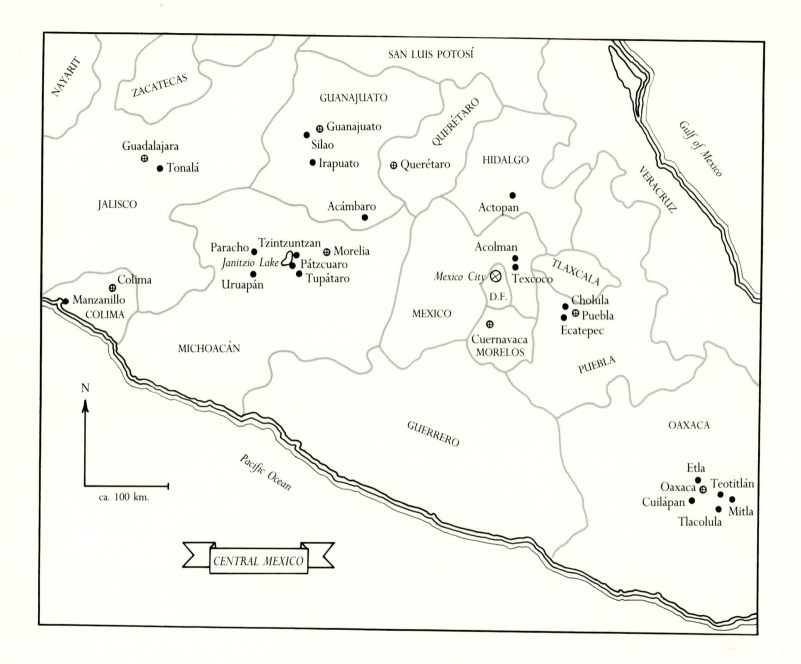

NAYARIT

ZACATECAS

SAN LUIS POTOSÍ

GUANAJUATO

⊕ Guanajuato

• Silao

QUERÉTARO

Guadalajara
⊕
• Tonalá

• Irapuato

⊕ Querétaro

HIDALGO

JALISCO

Acámbaro •

• Actopan

Paracho • Tzintzuntzan
Janitzio Lake ⊕ Morelia
 • Pátzcuaro
Uruapán • Tupátaro

Acolman •

Mexico City ⊗
D.F.
• Texcoco

TLAXCALA

VERACRUZ

Gulf of Mexico

Colima
⊕
• Manzanillo
COLIMA

MICHOACÁN

MEXICO

• Cholula
⊕ Puebla
• Ecatepec

⊕ Cuernavaca
MORELOS

PUEBLA

N

GUERRERO

OAXACA

Pacific Ocean

ca. 100 km.

Etla •
• Teotitlán
Oaxaca ⊕
Cuilápan • • Mitla
Tlacolula •

CENTRAL MEXICO

Mazatlán (map 1), Weston noted that he "made the first negatives other than matter-of-fact records—negatives with intention. A quite marvellous cloud form tempted me—a sunlit cloud which rose from the bay to become a towering white column, higher and higher to a glorious climax in the blue heaven—" (Plate 1).[11] Although he only wrote a few words about this image when he made it, it seems to have been the first time in his career that he had been sufficiently moved to photograph a cloud. It was a theme upon which he would elaborate at length in Mexico. Weston was only a few days away from his home, his family, his portrait studio in Tropico, and his responsibilities, but already he was experimenting with new subject matter. Soon he would also be involved in expressing his newfound freedom and artistic personality through landscapes and still lifes, themes in which he had shown no compelling interest when he lived in the United States. This trip was a release from the expectations, obligations, and commitments imposed upon him by his photographic practice, his family, probably also even his friends, and certainly by the environment in which he had been living.

But what did Weston know about what he was getting into, about what he would confront in Mexico as an artist and as a citizen of the United States?

In early December 1921, Tina's husband, Roubaix de L'Abrie Richey (Robo), a painter, left for Mexico. Later that month he wrote Weston a ten-page letter describing the picturesque possibilities to be found south of the border: "There is for me more poetry in one lone zerape enshrouded figure leaning in the door of the pulque shop at twilight or of a bronzen [sic] daughter of the Aztecs nursing her child in the church than could be found in L.A. in the next ten years." Robo was impressed by and excited about the amount of artistic activity in Mexico, especially by the fact that native sources were being employed rather than European ones, and by the way artists were seeking "to find themselves in themselves." He mentioned Weston's coming exhibition there, urged him to come to Mexico, and even offered to do advance publicity for him.[12] Robo's enthusiasm over the artistic paradise he had found, as well as Tina's later reports, seem to have influenced Weston considerably.

It is important to note that the United States' political attitude toward Mexico in the early 1920s demonstrated a fervent desire to continue colonializing that country and to ignore the recent revolution. The U.S. government

under President Harding did not recognize President Obregón, who had taken office in November 1920, a situation described by a journalistic observer as "silent warfare." In July 1923, the U.S. Senate held hearings on "outrages" suffered by U.S. citizens in Mexico.[13] These "outrages" were largely financial. Secretary of the Interior Albert B. Fall was pressing to obtain exemptions for U.S. citizens and companies from certain clauses of Mexico's 1917 Constitution, and warnings were issued that the rights and private property of U.S. investors were not being adequately respected. It was the general feeling of the establishment in the United States that foreign investors should be guaranteed against risks in Mexico, that as far as U.S. citizens were concerned, the accomplishments of the revolution should be ignored—all this at a time when 21 percent of the Mexican national territory belonged to U.S. citizens and companies. Harry Chandler, a distant cousin of Weston's wife, financed and directed a syndicate which, alone, owned 860,000 acres of Mexican land; his discontent was repeatedly reflected by the editorial policy of his newspaper, the *Los Angeles Times*. More than 57 percent of the Mexican petroleum industry was owned by U.S. investors; these oil companies refused to pay Mexican taxes, although lower than U.S. ones, and they begged for U.S. intervention. Katherine Anne Porter, who had grown up in Texas on the border and moved to Mexico in December 1920, commented that "so far as the oil people are concerned, they cheerfully admit it is cheaper to keep a few minor revolutions going than to pay taxes."[14]

When Calvin Coolidge succeeded Harding as president, it was discovered that Harding's secretary of the interior, Albert B. Fall, who had been responsible for formulating U.S.–Mexican policy, was on the payroll of Edward L. Doheny, an oil man who had enormous investments in Mexico. In late August 1923, the United States finally recognized Obregón's government.

This climate of opinion, combined with the general lack of journalistic coverage and scarcity of communications media, meant that very little factual or nonpartisan information on Mexico would have been available to Weston. U.S. Senator Ernest Gruening commented that in 1922, with one exception, "nothing, save some violently hostile tracts, had been published in the English language about the revolution."[15] In 1924, Porter admitted that of all the travel books on Mexico she knew of only two which she thought should "be rescued from the

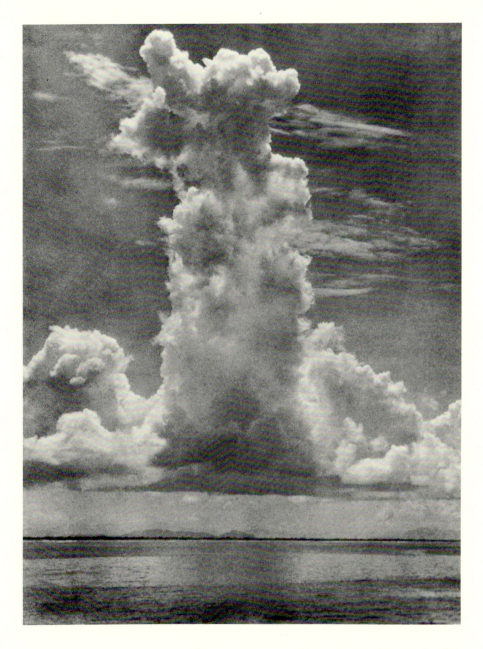

Plate 1 *"The Great White Cloud of Mazatlán."* 1923. Collection of the Oakland Museum, Oakland, California: Gift of Dr. and Mrs. Dudley P. Bell.

growing rubbish heap which is the literature about Mexico in the English language." In a review of one of the rejects, she wrote:

> The author believes the United States must eventually intervene down there, for Mexico's own shining good. . . . [because of] the wealth of that fabulous country. There are mines of gold and silver, mountains of iron and opals, seas of pearls and rivers of oil, fattened cattle and forests of fine woods. . . . Even the butterflies are more gorgeous in Mexico than elsewhere, it seems, and are being developed into a thriving industry for export.
>
> It is very discouraging. I had hoped they might overlook the butterflies.[16]

Weston probably should have considered the possibility of encountering harsh anti-U.S. feelings in Mexico. Nor could he realistically have believed that this trip would be a return to the purity of nature sometimes associated with underdevelopment. His friend Robo had died in Mexico City in February 1922 of an illness described in different sources as cholera, smallpox, or tuberculosis.[17] Mexican statistics from this time show that 15 percent of a random sample of active workers had T.B. and that death was caused by it twice as often in Mexico City as in the United States. Death from pneumonia was about seven and a half times higher in Mexico; from diarrhea and enteritis in those over two years old, about thirty-seven times higher; and from syphilis, more than seven times higher. In 1926 it was reported that about half the inhabitants of Mexico City suffered from this last disease; it was considered exceptional to have reached adulthood without having contracted it. The cost of living was relatively high, and life in Mexico was fraught with a degree of poverty, misery, and the social problems which reflect them that Weston could not have anticipated. Moreover, about 85 percent of the people were illiterate, although the government was expanding educational facilities on a scale previously unknown in Mexico. Indoor toilets and running water in private dwellings were still rare—and the lack of the latter certainly would have made washing prints difficult for any photographer.[18]

Robo had conveyed his excitement about the artistic situation in Mexico, and Weston knew that some of his prints had sold. By the time Edward left for Mexico, the artists Francisco Goitia, Jorge Enciso, Carlos Mérida, and Roberto

Montenegro had already created important plastic works recalling their indigenous roots, and Diego Rivera (Fig. 9), José Clemente Orozco, David Alfaro Siqueiros, Jean Charlot (Fig. 6), and Xavier Guerrero had painted murals in public buildings. The Sindicato de Pintores, Escultores y Grabadores Mexicanos (Union of Mexican Painters, Sculptors, and Engravers) had also been founded. There is no evidence, however, that written descriptions or reproductions of these accomplishments had reached Los Angeles.[19] It is likely, though, that Weston had seen the exhibition of 5,000 pieces of Mexican folk art and the shows of watercolors and drawings by Xavier Guerrero and Adolfo Best-Maugard which were shown in Los Angeles in November 1922.[20] He may also have read the catalogue by Katherine Anne Porter which accompanied the folk art exhibition and was the first work in English on that subject.[21] Not only had he known Gómez Robelo in late 1921, but a year later he met Xavier Guerrero and did his portrait.

In July 1923, the month when Weston left for Mexico, Porter described the artistic situation there in general terms:

> About three years ago I returned to Mexico, after a long
> absence, to study the renascence of Mexican art—a veritable rebirth,
> very conscious, very powerful, of a deeply racial and personal art. . . .
> It would be difficult to explain in a very few words how the Mexicans
> have enriched their national life through the medium of their native
> arts. It is in everything they do and are. . . . I like best the quality of
> aesthetic magnificence, and above all, the passion for individual
> expression without hypocrisy, which is the true genius of the race.[22]

The S. S. *Colima* arrived in Mazatlán on August 4. Edward, Tina, and Chandler strolled, drank beer, took snapshots, and looked. What most impressed Weston, according to the *Daybooks*, were the blocks of houses of pastel colors, the tropical fruits and flowers, and especially, the "sharp clashes of contrasting extremes, but always life—vital, intense, black and white, never grey."[23] They landed in Manzanillo, spent a day in Colima, another in Guadalajara, and finally reached Mexico City about August 11. They spent the first night in the Princess Hotel at Avenida Hidalgo 59. Once again, they were met by extremes: to the north of the hotel was the penitentiary, to the east, the colonial churches of Santa Veracruz and San Juan de Dios, to the south, fashionable

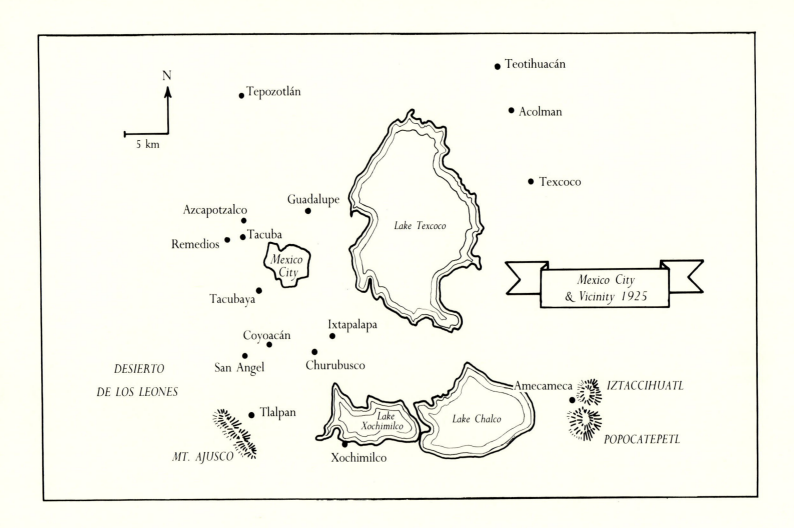

N

5 km

Tepozotlán

Teotihuacán

Acolman

Texcoco

Azcapotzalco

Guadalupe

Lake Texcoco

Remedios

Tacuba

Mexico City

Mexico City
& Vicinity 1925

Tacubaya

Ixtapalapa

Coyoacán

DESIERTO
DE LOS LEONES

San Angel

Churubusco

Amecameca

IZTACCIHUATL

Tlalpan

Lake
Xochimilco

Lake Chalco

MT. AJUSCO

Xochimilco

POPOCATEPETL

Alameda Park, and diagonally opposite, the eclectic and pseudo-neoclassic Teatro Nacional.

They soon moved to a ten-room hacienda in the suburb of Tacubaya (map 2). They called the house "El Buen Retiro." It was east of Mexico City and Chapultepec Park, west of the modern Anillo Periférico, today a forty-minute car ride from the center of the city. Weston signed a six-month lease, and they began to settle in. His snapshots emphasize the open space, the sense of isolation, and the simplicity of the architectural units. He realized that it was an impractical location, but he hoped to get around this by obtaining a telephone. He was immediately amused by the names of the pulquerías, the least expensive bars, such as "Las Primorosas" (The Beautiful Girls), "Sin Estudio" (Without Thought), and "La Muerte y la Resurrección" (Death and Resurrection). He was impressed, too, by the fine forms and colors of the inexpensive Puebla ceramic ware they purchased in the market, and, finally, he had his own room:

> I am to have one of my dreams fulfilled—a whitewashed room; the
> furniture shall be black, the doors have been left as they were, a
> greenish blue, and then in a blue Puebla vase I'll keep red geraniums![24]

A few days later he described his bedroom, which had just been finished. It was almost as he had planned it, except that the walls were light grey. The floor was darker grey; the cot in one corner had a brilliantly flowered woolen cloth thrown over it. He hung three prints on the walls, "Picasso [Fig. 2], Hokusai—and one of my own photographs—the 'Smoke-Stacks' [Fig. 8] of course—."[25] He had brought them to Mexico probably not only because of their intrinsic beauty but also because they represented stages in his own career.

The print by Picasso must have been *The Watering Place*, a drypoint from 1905.[26] The work is lyrical, but at the same time, the forms are simple and monumental; these are stylistic characteristics also seen in some of Weston's early work, such as his portraits of his son Chandler taken about 1912–13.

The second picture, by Hokusai, the prolific Japanese printmaker, has not been identified. Like much of Weston's work from his salon period, Hokusai's pictures are often characterized by sinuous line and movement, carefully balanced composition, figures cut off by the edges of the frame, and a flat sense of space juxtaposed with atmospheric perspective.

Figure 2 Pablo Picasso, *The Watering Place*. 1905. Fine Arts Museum of San Francisco: Achenbach Foundation for the Graphic Arts.

Figure 3 *Elisa Guerrero.* 1923. Courtesy G. Ray Hawkins Gallery, Los Angeles.

The third print was Weston's own photograph of smokestacks, taken in October 1922 at the Armco Steel Company in Middleton, Ohio. Alfred Stieglitz, Georgia O'Keeffe, and Johan Hagemeyer had all admired the print. It stands out among Weston's work because of the simplicity of the almost abstract forms, the effective manner in which they are balanced, and the way he exploited the photographic possibilities of both tone and texture.

Having carefully considered the harmony of the decor of his own room at El Buen Retiro, Weston hung three prints together: a drypoint, probably a woodcut, and a photograph. It did not seem to disturb him that the traditional processes were not customarily exhibited with the newer one, photography. Although he was probably unaware of it, this stylistic and technical mélange represents his creative and expressive development up to this point.

Through Tina he soon met the painter Diego Rivera, the cinematographer Roberto Turnbull, and renewed his friendship with Xavier Guerrero, with whom they dined at Los Monotes. Weston was impressed by the "humorous, grotesque, and Rabelaisian drawings"[27] that decorated the restaurant, apparently unaware that they were by José Clemente Orozco, whose brother owned the place.

By September 13, he had already arranged for an exhibition of his work at the Aztec Land Gallery to run for two weeks, from about October 22 until November 4. We do not know how he arranged this, nor do we have a satisfactory idea of exactly what he exhibited there. However, until he moved to his house on Calle Lucerna in the middle of September, he did not have a place to work. At that time he planned to include a few photographs which he had taken since his arrival in Mexico: one of Chandler, certainly the one that showed him seated on the cow-shed roof with clouds overhead, which was the first print he signed "Mexico, D.F."; at least two of Tina; and three of Elisa Guerrero, Xavier's sister, one of which he described as "Tehuana costume. A fine, strong face is recorded, an Indian face. Will she like it or will she wish to be pretty?"[28] He probably also included "*The Great White Cloud of Mazatlán*,"[29] which he had been working on with mixed emotions because the negative showed film deterioration.

He described some of the photographs which he planned to include as belonging "to a 'romantic' school not altogether in keeping with my present

frame of mind nor attitude towards my work." [30] He sold eight photographs from the exhibition: six nudes of his friend the photographer Margrethe Mather, made the week before he sailed, one of Elisa Guerrero in a Tehuana costume, and one that has not been identified.

Clearly the exhibition was not an economic triumph, but he was impressed by the sincere interest of those who came to see the show, between 800 and 1,000 visitors. In his *Daybooks* he mentioned many of them by name: Diego Rivera; the archaeologist Ramón Mena; his friend Ricardo Gómez Robelo; Adolfo Best-Maugard, the art educator; Dr. Atl, the painter, art historian, and volcanologist; Nahui Olín, the poet and painter (Fig. 17); and Diego's wife, Guadalupe Marín de Rivera, whose presence and appearance impressed him greatly.

Edward and Tina were soon popular in artistic circles; they attended the opening of the exhibition of Rafael Sala's paintings, Diego's birthday party, and the receptions given by the wealthy industrialist Tomás Braniff where Weston met the French painter and printmaker Jean Charlot in late November.

Three of his new friends would be particularly important for his activity in Mexico: Monna Alfau, a writer; her husband, the painter Rafael Sala; and Jean Charlot (Figs. 4–6). Certainly these relationships were encouraged by the fact that all those involved spoke English.

Monna Alfau and Rafael Sala were both Spanish; they met in New York about 1920. She had been trained as a librarian; he was a painter and had had a one-man show in New York in March 1923.[31] In 1923 they came to Mexico on their honeymoon to visit Felipe Teixidor, Rafael's closest friend from Spain, and they stayed. They met Weston at his Aztec Land exhibition. The couple often went on outings with him, to places such as Tenayuca, Churubusco, San Juan Teotihuacán and the Pyramids, to the fiesta of the Virgin of Guadalupe, to Tepotzotlán, to San Cristóbal, and to Azcopotzalco.[32] They introduced him to Senator Manuel Hernández Galván and to the sculptor Manuel Martínez Pintao. Weston photographed objects they had acquired such as Monna's rag doll, their boxes from Olinalá, their painted petate, and their Oaxacan sugar bowl. They introduced him to aspects of Mexico that he might otherwise have missed. He respected their criticism and taste. "Monna's opinion," he wrote, "is always of interest to me." When he was back in Los Angeles he referred to them as among his "best friends." While in Mexico he wrote: "in mentioning close friends I do

Figure 4 *Monna Alfau Laughing.* 1924. Private Collection. Figure 5 *"Rafael Sala," Seated.* 1924. Private Collection.

Figure 6 *"Jean Charlot."* 1926. Jean Charlot Collection, Thomas Hale Hamilton Library, University of Hawaii at Manoa, Honolulu, Hawaii. Figure 7 *"Caballito de Cuarenta Centavos"* or *"Horsie."* 1924. Collection of the California Museum of Photography, University of California, Riverside: Extended Loan from Hardie C. Setzer.

not overlook the Salas. I have seen more of them than any other 'person, but it is collectively that I always think and speak of Monna, Rafael, Felipe, and their unavoidable dogs."[33]

On the same occasion, Weston wrote: "Jean Charlot remains as the one whom I am most strongly drawn towards. . . . Charlot is a refined sensitive boy, and an artist." They understood each other like colleagues. "Charlot in looking over my prints laughed outright, then flushed confusedly. 'I laugh so at times when I am emotionally stirred.'"[34] Later Charlot wrote to Weston: "Write me please. There are so few people who *live* for art."[35] They seemed to have had an exceptionally spontaneous relationship: they boxed, Charlot did caricatures of one of Tina's suitors, he drew on Tina's back, and several times he tried to steal one of Edward's toys, a Chinese-looking horse, but Edward finally gave "Horsie" to him, and he, in turn, gave Edward a caricature of it. Charlot admired and collected Precolumbian art, and helped to introduce Edward to it. He worked with the muralists, including Rivera, and Weston later considered his work superior to Diego's. He introduced Weston to the painter Carlos Mérida; he accompanied him when he photographed pulquerías. He may have introduced Edward to Anita Brenner, for Jean and Anita were close friends, and may have encouraged her to include Weston in her contract with the university, which gave him the opportunity and the funds to travel from Oaxaca to Guadalajara in 1926. Charlot probably arranged for Weston to participate in the spring 1924 exhibition in Guadalajara, where apparently he sold eight prints. They exchanged works, and Rafael, Jean, and Edward showed together at the Café de Nadie.

This exhibition was held in Mexico City on 12 April 1924. Even though Weston showed only six prints, and was not mentioned on the poster, this show may have affected his stature in Mexico because, by exhibiting on this occasion, he was publicly aligning himself with the modern art movement in Mexico. He described it only briefly: "Today, in El Café de Nadie, Avenida Jalisco, I am showing six photographs under the auspices of Movimiento Estridentista. . . . The exhibit is in charge of Maples Arce, editor of *Irradiador*. Others showing are Jean Charlot, Rafael Sala, and masks by Cueto."[36] The exhibition also included paintings by Ramón Alva de la Canal, Fermín Revueltas, Leopoldo Méndez, Máximo Pacheco, and Xavier González. Maples Arce and German List Arzubide

read their own poetry. Five thousand entrance tickets were sold to this "Te-Invitación," sponsored and organized by the estridentistas.

The first estridentista manifesto was published in 1921, apparently as a reaction to World War I, to the Mexican Revolution, and to hypocrisy in general. In 1922 Maples Arce wrote: "Estridentismo is not a school, it is not a tendency, nor is it an intellectual mafia, as it has been described here; estridentismo is a message of strategy. An expression. An irruption." [37] The headlines on the third manifesto, published in October 1923, read "Death to Intellectual and Mummified Reactionaryism." [38]

Carleton Beals described the movement as: "And so expressionism. . . . The Noisemakers—the Estridentistas! They have to shout to be heard. They have shouted. Hence Estridentismo. Noisy-ism!" [39] Elsewhere he added: "Spanish America has lived under three literary influences: that of Spain, that of France, and of the estridentistas of Xalapa." [40]

Anthologies of Mexican poetry published in 1916, 1919, and 1920 include almost exclusively poems dealing with subjects such as the sea, dawn, and flowers. The poets show a "complete divorce from the Mexican scene. . . . They write in a void unrelated to earthly existence." [41] In 1921 Katherine Anne Porter described the same phenomenon:

> Here in Mexico there is no conscience crying through the literature of the country. A small group of intellectuals still writes about romance and the stars, and roses and the shadowy eyes of ladies, touching no sorrow of the human heart other than the pain of unrequited love.
>
> But then, the Indians cannot read. What good would a literature of revolt do them? [42]

The estridentistas admired not nationalism, but rather a sense of place; they refused to romanticize the revolution; they respected it as a subject for art, not as a motivation; they saw "no need for revolutionary rhetoric and sophistry." [43] The most prominent artists supported the movement "for its desire to break old moulds and heavy structures" and because of its "rebellious and unsubmissive spirit." One of its founders described it as: "An anxiety to break with an ambient that we felt instinctively was strangling us. We saw later that it was a rebellion that was in the air of the world. . . . It called to the youth of Mexico to search for new directions. . . ." [44]

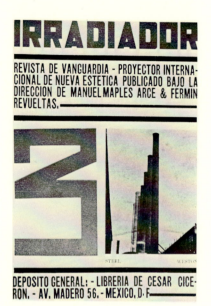

IRRADIADOR

REVISTA DE VANGUARDIA - PROYECTOR INTERNA-
CIONAL DE NUEVA ESTETICA PUBLICADO BAJO LA
DIRECCION DE MANUEL MAPLES ARCE & FERMIN
REVUELTAS.

STEEL WESTON

DEPOSITO GENERAL: - LIBRERIA DE CESAR CICE-
RON. - AV. MADERO 56. - MEXICO, D. F.

Figure 8 Cover of *Irradiador*, no. 3, 1924, with Ed
ward Weston's *"Smokestacks"* or *"Steel"* from 1922.

The estridentistas "presented rabble-rousing opinions designed to cause inquietude, anguish, instability, and simultaneously, distress among those who were poets by habit."[45] At the same time, they were quick to praise the modern world that surrounded them. Diego Rivera commented, according to Weston: "'If I went there [New York City] . . . I believe I should turn to painting billboards and posters.' He spoke of the machine, 'There is so much beauty in the steel door to a safe-vault. Perhaps future generations will recognize the machine as the art of our day.'"[46] Some of the best-known poems by the estridentistas were titled "Urbe" (City) and "Radio"; their magazine was called *Irradiador* (Radiator); all of these subjects were, of course, reflections of modern life that would have been rejected as unworthy themes for art by romantics or pictorialists. The word *Bolshevik* was occasionally used in estridentista writing. It did not connote anything about communism or the Soviet Union, however, and it has to be translated as *revolutionary*.[47]

Probably because of its disrespect for tradition, its penchant for literary puns, and its admiration for technology and industrialization, estridentismo has been likened to futurism. However, the alienation and disillusion characteristic of the latter movement are not present. If it must be likened to an already established movement, Beals's reference to expressionism seems more valid, since the driving force behind it was also spontaneity or release, which, however, was consistently interpreted in a figurative and relatively meaningful manner.[48]

Most of Weston's artist-friends, including Rivera, Charlot, Quintanilla, and Cueto, were involved with the estridentista movement, even though they may have rejected the label. The artistic revolution seems to have been accepted as the status quo, and Weston's innovations and manifestations of iconoclasm were admired, understood, and accepted as normal. His photograph of smokestacks was published on the cover of one of the three issues of *Irradiador*; his formalist portrait of Ruth Shaw was used to illustrate List Arzubide's 1926 book, *El movimento estridentista*; and his view of a toilet from above was given a full page in a 1928 issue of *Forma*, a magazine that was an offspring of the movement.

The advent of estridentismo coincided neatly with the emergence of the nationalist cultural movement and with the new appreciation of Mexican art by Mexicans. It is not possible to separate the contribution of each of these forces in the formation of the cultural situation. Although the two movements con-

centrated on the importance of place, they were distinct; the estridentistas rejected propaganda and anything that resembled flag waving; the muralists emphasized Mexico's past. Both forces were also highly figurative; neither demonstrated interest in an art-for-art's-sake aesthetic. The two shared an almost unquestioned acceptance of an intimate relationship between environment and art. Discussing Rivera's murals and the nationalist movement, Beals wrote: "The secret is Mexico in revolution, in turmoil; tortuously discovering itself at the cost of brutality and bloodshed and thwarted ideals."[49] Almost simultaneously, in a 1925 letter to Edward, Tina wrote: "And here I know exactly that you will answer = '*Art* cannot exist without *life*—'"[50]

In 1921, under President Obregón, the humanist and writer José Vasconcelos was appointed minister of public education, a position he filled until President Calles took office in 1924. Vasconcelos was determined to fulfill part of the mandate of the Mexican Revolution by incorporating the Indian in society, partly through public education and the promotion of the aesthetic accomplishments of Mexicans in Mexico. His work was facilitated by the relative isolation of Mexico from the United States, England, and France at that time. Vasconcelos funded and supported major archaeological and anthropological studies of Mexican cultures and monuments, such as those by Manuel Gamio on the temples, valley, and people of Teotihuacán, and by Ricardo Gómez Robelo on Nahuatl symbolism.[51]

Vasconcelos appointed Adolfo Best-Maugard director of drawing in the Department of Fine Arts. Best-Maugard had realized the innate spontaneity and feeling conveyed in much Precolumbian and popular art and had devised a simplified system of drawing, based on a few select motifs found throughout Mexican art. The system was published in 1923 as *Método de dibujo, tradición, resurgimento, y evolución del arte mexicano* (*Method of Drawing, Tradition, Reappearance, and Evolution of Mexican Art*);[52] it was tried out and taught in a vast number of rural and urban schools which Vasconcelos had founded. The motivations for creating and spreading such a system, of course, were to revive racial and national consciousness through the study of Mexican art, and to make it possible for anyone with minimum training to express himself visually, even if in a limited fashion. Vasconcelos also sponsored evening and weekend art schools for workers and encouraged a revival of folk dances. The aesthetic accomplishment for

Figure 9 *"Diego Rivera" Smiling.* 1924. San Francisco Museum of Modern Art, Evelyn and Walter Haas, Jr., Fund Purchase (83.20).

which he is probably best known was the patronage of the mural painters: first Dr. Atl and Roberto Montenegro; then Diego Rivera, José Clemente Orozco, David Alfaro Siqueiros, Xavier Guerrero, Jean Charlot, Fermín Revueltas, and about eighteen others. He justified this project by explaining that public painting on public walls would improve the Mexican self-image. He apparently did not censor or direct the works of individual artists, although he was quoted as having said, while looking at one of the murals: "I heartily dislike what you are doing. It is terrible! But the wall is yours—Go ahead!" [53] A surprising number of religious scenes were painted initially, but the muralists rapidly directed themselves to themes designed to inspire the Mexican people, including Mexican symbolism, local social problems, native types, and a somewhat utopian account of Mexican history. At the time, these works were considered ugly by many people who had some familiarity with European art and had been conditioned to appreciate imported cultural values, such as inoffensive impressionist landscapes and blonde madonnas.

About 1924 Diego Rivera described this situation:

[The bourgeois] has not only aspired to be altogether European in the manner of his ill-chosen masters of art, but he has attempted to dominate and deform the aesthetic life of the true Mexican . . . and his failure to do this has created in his mind a profound rancor against all native things, all art expression truly Mexican. He has so fouled the atmosphere that for a century art in Mexico has been almost stifled.

He accepts without discrimination the dubious cultural influences of Europe, not only in one style, nor from one country, but from all. . . . This catholicity of corrupt appetite has spoiled his palate for the pure beauty to be found in America. . . . If you should ask him for a reason [for rejecting native art], he would answer, in effect: "Indian art? Absurd! What can a peon know about beauty?"[54]

This national inferiority complex was noted and described by Weston as soon as he arrived in August 1923:

The middle class Mexican has no better taste than the bourgeoisie of any other nation, in fact the store windows are a conglomeration of the most tawdry rubbish I have ever seen—I have reached here evidently in time to see the end of Old Mexico—it is slowly becom-

The Obregón government, however, was trying to alter this situation, to entice Mexicans into reappraising and eventually esteeming their own heritage and culture. A monumental exhibition of Mexican popular art, organized by the artists Jorge Enciso and Roberto Montenegro, was sponsored by the government to commemorate the one-hundredth anniversary of the consummation of independence.

The display of popular art was a radical contrast to what had been done a decade earlier to celebrate another centennial, that of the proclamation of independence. For this occasion, in 1910, President Díaz had imported an exhibition of Spanish painting and had ordered the construction of the Palace of Fine Arts, the Teatro Nacional. The building was designed by Italians, the survey and foundation were carried out by North Americans, the marble statues were carved by a Catalan, the facade sculpture and dome were planned and carried out by Italians, the marble was imported from Carrara, and the crystal screen was executed by Tiffany in New York—all while the building rapidly sank into the ground. This embodiment of Mexico's cultural inferiority complex did not go unnoticed by Weston:

> Porfirio Díaz, that tyrant of bad taste, imported Italian "art,"—
> portrait busts, fountains, monuments, the "Teatro Nacional." Enough
> said! With his vulgar mind he of course had no understanding of the
> more intelligent finer Indian. He should have been dethroned for
> aesthetic reasons, not political. In such a revolution I could joyfully
> take part! [56]

The exhibition of Mexican popular arts was inaugurated by President Obregón in September 1921. According to both Jean Charlot and Dr. Atl, it was warmly and widely received. Soon, Dr. Atl maintained, people of good taste were redecorating rooms or corners of their homes in the style of the exposition.[57]

In 1922 the Ministry of Industry and Commerce published a greatly expanded version of Dr. Atl's 1921 catalogue, *Los artes populares*.[58] The second edition consists of a generic survey of different types of Mexican popular art—

from saddles to songs. Probably Weston was familiar with this study, for he often dealt with the same subjects. Clearly, however, he did not use it as a stylistic source; its photographs, tipped in like art works, are static, symmetrical, evenly illuminated, and archival in character.

Another manifestation of the influence of this exhibition is Manuel Romero de Terreros y Vinent's book *Las artes industriales en la Nueva España*, published in 1923. It was intended for a more serious audience than was Atl's work; it outlines in detail the specific history of each of the arts and is admirably documented. Since the book was well received, the entire bourgeoisie could not have been quite as disdainful of its heritage and environment as Rivera had claimed. Weston probably also knew this work since he photographed a half-dozen of the objects Romero presented as outstanding prototypes.[59]

Weston's attraction to Mexican art gradually evolved and grew subtler as he became more acclimated. In his first weeks in Mexico he criticized the Americanization of life there and often compared life in Mexico to that in the United States. He was impressed by art that often appealed to tourists, but these things excited him more than they did the average tourist. By 1926, his taste had become considerably more refined. For example, when setting up house at El Buen Retiro, he was delighted by the inexpensive modern Puebla ware. A few weeks later, he wandered through the stands at the market and bought two lovely Jalisco dishes which he spotted among "much utter rubbish made for the tourist. . . . [and noted] booths filled with both atrocities and work of the finest craftsmanship; it is evident that the Indian's work is becoming corrupt, and with another generation of overproduction and commercialization will be quite value-less."[60] Three years later he was searching out the finest modern ceramic ware in Mexico like an expert and was describing in detail the shape, design, and techniques employed:

> Sr. Solchaga had first shown us this pottery, [green, glazed ware from Patambán]—then, seeing my delight, presented me with an exquisite dish. The pattern is almost always a vivid green on a brown-black ground,—sometimes a touch of ivory is introduced. The better dishes are painted underneath,—green and ivory patterns over the natural red-brown clay. If it came to parting with all my pottery but one piece, this green dish from Sr. Solchaga would be under consideration

as my favorite. For in it all the Indian's imagination, their lyrical spirit, their plastic reconstruction of nature is manifest in essence. Chained to the outer edge of the plate, a little animal, maybe a deer, balances on leaf sprays. No deer could stand on such delicate stems, but what cares the Indian for humdrum truth?[61]

This same refinement in Weston's sense of critical judgment also applied to his assessment of mural work. About 21 August 1923 Tina and Edward went to see Diego Rivera's murals, probably at the Ministry of Public Education, and he commented:

> It was the work of a great artist which we viewed. . . .
> After the inspiration of Rivera and his painting, I received a severe let-down. We went to Sanborn's. What was once a marvellous palace of blue tile has been redecorated, turned into a typical American restaurant.
> The murals of Diego Rivera have raised a storm of protest from the conservatives, but the work continues on. I cannot imagine his having the opportunity to start such paintings in any American municipal building. Government "of the people, by the people, and for the people" does not foster great art.[62]

About two years later, on 20 November 1925, he went with the writer Carleton Beals to see Diego's most recent murals at the National School of Agriculture in Chapingo. Later he remarked:

> The ceiling and top panels were almost complete. Two tremendous nudes dominated the room—to the right a prone figure from a drawing of Tina—to the left a semi-erect figure from Lupe—both majestic monumental paintings. The ceiling with figures in exaggerated perspective was intellectually provocative, stimulating, but effort and calculation were more evident,—while the first mentioned nudes were presented with such grand manner as to bring no questioning. They are worthy of anyone's pilgrimage and homage.[63]

On December 17 he again looked at Diego's work critically:

> . . . Diego, unless he gets out of his rut, has reached his limit; he is going around in circles, repeating successes, but cold and calculated in their formulization.[64]

Evidently Weston had developed greater critical confidence and had learned to analyze other art forms in the same way that he analyzed photography years before.

When he first arrived in Mexico City he was extremely impressed by the Spanish Colonial architecture; he commented on his reactions to the Cathedral of Mexico City, the Convent of Churubusco, the Monastery of San Angel, the Church of Santa Anita, the Church and Monastery at Tepotzotlán, the Church of San Agustín Acolmán, and the Church of La Santísima in Mexico City. The lack of entries about architecture later in the *Daybooks* suggest that he lost interest in the subject, with, of course, a few exceptions. He did not often photograph the churches, except for snapshots which have rarely survived, such as those he took of Tepotzotlán with his Graflex camera, for "recuerdos [memories]." Earlier, he had commented:

> El Convento de Churubusco is a gem. I think it is the loveliest of the churches I have yet seen, though they should hardly be compared—each having its own special charm. Churubusco is intimate, I wanted to linger and rest in its tiny patio, to caress its mellow tiles, to worship before its lovely golden virgin.
>
> The rest of the party made photographs, one man being a wealthy amateur. I did not, for the churches in Mexico are an end in themselves, needing no further interpretation. I stand before them mute—nothing that I might record could add to their beauty.[65]

Certainly, combined with the realization that not all beauty could be translated into photographic terms was a conscious or unconscious fear of being picturesque, that is, photographing that which was expected to impress the tourist: the exotic, the theatrical, and the underdeveloped. He commented on this inquietude:

> I might call my work in Mexico a fight to avoid its natural picturesqueness. I had this premonition about working in Mexico before leaving Los Angeles and used to be almost angry with those who would remark, "O, you will have such a wonderful opportunity to make pictures in Mexico."[66]

Perhaps his fear of being picturesque, his realization that not everything attractive is potentially photographic, and his deepening appreciation for Mex-

ican art would explain his attitude toward the pulquerías, the lower-class bars. He noted and listed their colorful names from the moment he arrived: "The Pearl of Piety," "Hope in the Wilderness," "An Old Love," "The Camelia," and many others.[67] He did not, however, comment on the joy he received from the paintings which decorated their facades until 5 May 1924, although he could not have avoided seeing them before then.

> Then we came upon several examples of contemporary decoration which excited our aesthetic senses quite as profoundly, if differently [from the Spanish Colonial churches]; they were pulquerías. Assuredly there must be a "school" of pulquería painting, for though diverse, they have the same general trend in color, effect, and design.
>
> If Picasso had been in Mexico, I should feel that he must have studied the pulquería paintings, for some are covered with geometrical shapes in brilliant primary colors to excite the envy of an European modernist. These paintings which include every possible subject, beautiful women, charros, toreadors, "Popo" and Ixtac-cíhuatl, engines and boats, are the last word in direct naive realism. With the titles emblazoned over the doors, imaginative, tender, or humorous, one has in the pulquería the most fascinating, interesting, popular art in modern Mexico City.[68]

The heightening of Weston's critical judgment was similar to that which was taking place all over Mexico. In September 1921, on the occasion of the opening of an exhibition at the Fine Arts Academy, no one less than Dr. Atl had stated: "As for students who cannot be turned into artists . . . they still have a chance of earning their living as pulquería painters." By July 1923, Diego Rivera had indicated that he would consider it an honor to be a pulquería painter.[69] There is no record, however, that Weston ventured out to photograph or to record the pulquería paintings until the middle of 1926.

By early July 1924, he had decided to return to the United States and obtained complimentary railroad passes, although only a few months before, he had written to his wife: "I still think—no matter what has been the cost—that this separation has been the best thing for us all—it has given a perspective which could not have been possible close at hand—and for me re my work—it has clarified my vision and attitude—enabled me to destroy much of my past

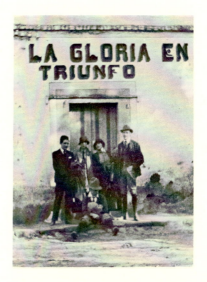

Figure 10 Unknown Photographer, *Edward Weston Seated in Front of the Pulquería "La Gloria en Triunfo" with Rafael Sala, Monna Alfau, Tina Modotti, and Felipe Teixidor Standing Behind Him.* 1926 (?). Private Collection. Figure 11 *Matador and Arena (Pulquería).* 1926. Jean Charlot Collection, Thomas Hale Hamilton Library, University of Hawaii at Manoa, Honolulu, Hawaii.

and build on firmer future—"[70] He missed his other sons, however, and he suffered from the unpredictability of his portrait sittings which, of course, accounted for most of his income while he was in Mexico. He described his own inquietude:

> It is the instability of Mexico which is maddening: a land so
> rich, so beautiful; a race, the Indians, so tender, lovable; but all
> smeared over with a slime of political intrigue and treachery in which
> my own country has played its shameful part.[71]

His friends gave him going-away presents; on July 30, only two days before the passes expired, he wrote:

> After a terrific inner struggle, both emotional and intellectual, I finally
> realized, and decided I must stay. . . . Mexico seems my only hope, I
> have nothing else. So I had to say to myself: "Wait. Do not act too
> hastily. Time—even a month or two—may change everything."[72]

He did return to Los Angeles in late December of that year but in the six extra months that he stayed in Mexico on this trip, he developed a fascination for a new subject matter. It was during this period that he experimented at length with still life for the first time in the twenty years that he had been practicing photography,[73] becoming deeply interested in toys (*juguetes*). Superficially his photographs of toys seem playful, and often the pleasure and humor he felt is still contagious. These pictures reflect his self-confidence, as well as his demanding tastes and preferences. He did not accept mediocrity in craftsmanship, nor in arranging and illuminating the objects. To him, the toys were not cheap objects destined to be broken and thrown away. Instead, he called them "major art." "What grace!" he exclaimed. "What elegance!"[74]

In Weston's pictures of *juguetes* neither photograph nor object is subservient. He managed to balance the two; he did not dominate his subject, which might have been condescending, both politically and aesthetically, nor did he allow his subject matter to dominate the composition, which in this case, would have been considered picturesque. The photographer and the object interrelated in order to exploit the best of each other, so that the subject matter was virtually the relationship, the reaction, betweeen the object and the photographer. He interpreted this:

Plate 2 *"Juguetes Mexicanos"*: *"Ragdoll and Sombrerito."*
1925. University Library, Special Collections, University of California, Santa Cruz.

Figure 12 *Petate Woman in Front of an Aztec Chair.* 1926. Courtesy Daniel Wolf, Inc., New York. Figure 13 *"Mexican Toys": Bull, Pig, Horse, and Plate.* 1925. San Francisco Museum of Modern Art, Byron Meyer Fund Purchase (81.106).

I have made the juguetes, by well considered contiguity, come to life, or I have more clearly revealed their livingness. I can now express either reality, or the abstract, with greater facility than heretofore.[75]

He also recorded his reaction to the toys he chose to work with:

I never tire of the juguetes, they are invariably spontaneous and genuine, done without striving, fancied in fun. One imagines the Indians laughing and joking as they model and paint.[76]

Recalling the adjectives Weston used to describe Mexico and the Mexican people—"beautiful," "loveable," and "tender"—it is reasonable to wonder whether the toys symbolized, for him, the people who made them and even represented Mexico itself.

Weston had received a pair of naive, realistic figurines for his birthday in the spring of 1924, and he had sent woven reed horsemen, known as Panchito Villas to his sons Cole and Neil in California for Christmas. Tina, in turn, had given him a Panchito Villa for Christmas. But his intense work with these toys between July and December 1924 was important in sensitizing his eye to the subtleties of Mexico and fomenting in him a compulsion to return later.

His first mention of photographing toys does not occur until early May, when he described a picture he had made of a Panchito Villa which "halts, saluting, before a mountainous basket; it is humorous, has good technique."[77] He dedicated considerable time and energy to this subject matter in the second half of 1924, and in this period he specifically mentioned his delight in a bull, horse, and pig made of clay, a metal "charro ahorse with raised banderillas," a "long-legged, pink-legged, lamb, with its silliest of faces," "a magenta-colored dog mouthing a green basket, excellent in form, . . . a wildcat biting into a green snake. . . ." Sometimes he also recorded working with them:

. . . two fishes and a bird on a silver screen; head of a horse against my petate. . . . The bird is a beauty indeed—a blue heron, bill and feet red, neck turned over its back to almost a completed circle—a lovely thing in line, but done by nature (albeit nature improved by man) for the bird is a painted gourd. However the horse ["Horsie," Fig. 7] and leopard owe nothing to nature but inspiration. The horse is Chinese in feeling—a 7th century porcelain perhaps!

A short while later, he noted: "So today I became happy for a while: I photographed more of my 'juguetes Mexicanos.'" Specifically, he mentioned three good negatives he had made of two little blue birds, "exquisite things in line."[78] He worked with the birds extensively, and his compositions were the results of several arrangements, several exposures, and considerable thought.

From a purely practical point of view, these still lifes also satisfied him in another way; he could play with his toys at home while he waited for people to telephone to make appointments for portrait sittings, which was, of course, how he made his living in Mexico.

When Weston's Mexican portraits are mentioned, one immediately recalls the heads of Hernández Galván, Tina Modotti, Nahui Olín, Diego Rivera (Figs. 15, 1, 17, 9), Lupe Marín, and D. H. Lawrence. These were probably of very little financial importance for him, since the subjects were often his friends and among the most progressive intellectuals in Mexico; probably he hoped that they would be salable to a wider audience. Moreover, it was most likely a pleasure to work with these subjects since they respected him as an artist and generally shared his political views. But this was not always the case. While his 1923 Aztec Land exhibition was still hanging, he noted:

> Just now an American girl came in for an appointment. "Do you
> know," she said, "that you are the talk of Mexico City? No matter
> where I go—to afternoon tea, to card parties—your exhibit seems to
> be the principal topic for discussion. You have started out with a
> bang!—already famous in Mexico!

As if in response, a few pages later he exclaimed: "Bah! for professional portraiture!" He concluded that to save his own sanity he had to invent a formula for professional portraiture. Later he decided to tank develop these pictures, as opposed to his personal work, and to pay a retoucher. "My one regret is that I must sign these prints; may they soon fade into obscurity!"[79]

He rarely recorded the names of his sitters, but those which have been located are very fine examples of commercial portraiture at that time, but in a few instances he described sittings that he found ridiculous or even horrendous:

> My days pass monotonously enough, trying to make an ancient
> American woman, dressed in a black mantilla, look like a Spanish
> señorita, retouching hours at a time—

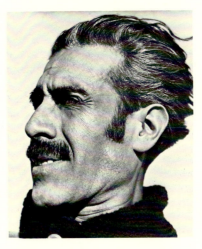

Figure 14 *"Three Fish—Gourds."* 1926. Collection of the International Museum of Photography at George Eastman House, Rochester, New York. Figure 15 *Manuel Hernández "Galván—Shooting."* 1924. San Francisco Museum of Modern Art, Purchase (62.1183).

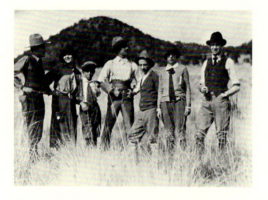

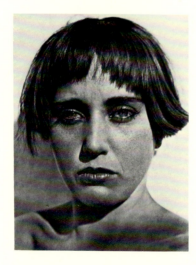

Figure 16 Unknown Photographer, *Felipe Teixidor, Tina Modotti, Pepe, Manuel Hernández Galván, Edward Weston, Monna Alfau, and Rafael Sala in the Countryside.* 1924. Private Collection. Figure 17 *"Nahui Olín."* 1923. San Francisco Museum of Modern Art, Extended Anonymous Loan.

Celebrated my birthday by putting in hellish hours of hard work. First my student—a session of pretended profundity. Then a sitting, members of a wealthy Mexican family,—mother, child and dogs: the mother alone, the daughter alone, the dogs alone, the mother and daughter together, the dogs and daughter together, until my brain was a muddle of mother, daughter and dogs, wriggling and posturing, barking and smirking.

But O! the memory of that sitting! The maddest jumble of grandmother—grandsons—granddaughter—great grandchildren—sons—and daughters—in every conceivable combination. . . . I photographed the young señora in exactly the same position she was painted by Zuloaga,—then copied the painting for her.[80]

A list of a few sitters can be reconstructed from reviews and hearsay. Some of his subjects must have exposed him to political and economic concerns and opinions that he would not have heard at the Friday night parties he attended with his friends. For example, among his sitters were Mr. and Mrs. Oscar Braniff and Tomás Braniff with his lover Luisa Dandini. The Braniffs were among the wealthiest Mexican landowners and industrialists, and Tomás enjoyed entertaining the intellectuals. Another sitter was Patrick O'Hea, an extremely influential British businessman and importer. Harry Wright, a steel magnate and president of the Mexico City Country Club, also sat for him.[81]

Outwardly provoked by an exhibition catalogue from Los Angeles, and frustrated by his desire to answer only to himself—which is exactly what his commercial portrait work did not permit—he wrote:

This is an age of "scratch my back and I'll scratch yours." I am guilty too. Afraid to offend with my true opinions for fear of ten centavos loss. I should like to test myself someday with just enough money ahead to allow of snapping my fingers at public opinion.[82]

Weston did include both professional and personal portraits in his second exhibition at the Aztec Land Gallery, which lasted from October 15 until October 31, 1924. Three reviews of this show concur that the exhibition created a sensation. Soon after he canceled his departure, he set a date for this show and decided that it would include only works he had done in Mexico.[83]

This show was particularly important for him. He had been working in

Mexico for a little more than a year; now he had a deadline, and he had to evaluate his own work, visually if not verbally. Succinctly, and rather nonchalantly, he commented: "Yes, my work is far in advance of last year; the striving, the sweat—though expended—is not so obvious in the prints." [84]

From Weston's own writings, a small part of this exhibition of between 70 and 100 prints can be reconstructed. He noted that he sold 6 prints (although the buyer of the nudes eventually reneged). These were a nude of Tina, an earlier nude of Ruth Wilton, one of Marguerite Agniel, titled "*Dancer's Legs,*" a "*Pirámide del Sol,*" a palm tree, and a head of his son, Neil. Dr. Atl was favorably impressed with the picture of Colonia Condesa, a work probably similar to the two that have survived. In a fit of jealousy, the Mexican photographer D. Silva destroyed the print Weston referred to as "*Torso.*" The photographs of clouds and Mexican toys, as well as the heads of Hernández Galván, Lupe Marín de Rivera, and Nahui Olín were particularly well received. So impressed was José Vasconcelos by Weston's pictures of clouds that he asked for seven prints to publish in his magazine *Antorcha.* Diego Rivera's favorite photograph was the "*Circus Tent* (Plate 3)," but he also liked "immensely" the "new still lifes of fishes and horses and birds," especially the "*Caballito de Cuarenta Centavos*" (the Chinese-looking horse), and the "*Clay Fruit.*" [85]

In his *Daybooks* Weston evaluated the exhibition:

> I have had—as last year—applause; real homage—yes, even more than last year—. . . . I am pleased, not satisfied, with my prints as they display themselves to me on the wall. No question but that I have gone ahead. And then comes the question, what next?
>
> I have assured sittings ahead, so something has been accomplished besides glory; but the glory has been sweet and I shall ever be grateful to the Mexicans for their fine attitude and appreciation. [86]

Apparently Weston was not exaggerating. The public was deeply moved, never having seen an exhibition of such expressive modern photography before. [87] So strong was the emotion elicited by the Aztec Land show that Francisco Monterde García Icazbalceta wrote the following prose poem about it and published it as a review:

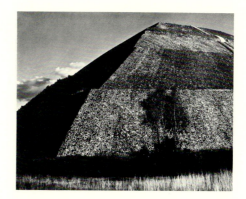

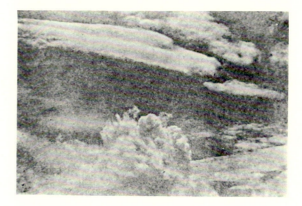

Figure 18 *"Pirámide del Sol," Teotihuacán.* 1923. San Francisco Museum of Modern Art, Promised Gift from Brett Weston. Figure 19 *Cirrus and Cumulus Clouds.* 1924. From "El Cielo de México," *La Antorcha*, 15 November 1924, p. 20; Private Collection.

The pupil of Weston's eye, circumscribed and clarified by his lens, is like a gunsight, and we have been presented with its conquests.

He has looked through it, like through a telescope—actually a Cyclops—to catch medallions of clouds, molded in high relief.

Encountering his aqueducts that go on stilts, one shrinks, becoming a citizen of Lilliput, and pulls up part of the circus tent, pale with the trapeze artist's daring, with a childlike anguish, thinking about Monday morning.

And, in the sea fields, his periscope steals fragments of the tide, frozen, like Niagara in winter.

From the light of his magic lantern emerge—enlarged—the Indian toys, the soul made out of cardboard, of reeds, and of clay: the profile of a little horse on wheels; the agrarian attitude of dolls with weapons, riders on the mules of Corpus Christi, and the sonorous silliness of the piggy-banks pretending to be fruit, posed on top of the bowls made from gourds that we discovered barely three years ago.

In order to portray ladies, Weston puts on a diplomat's monocle.

Like a lord, he looks at them from above, downwards, creating a distance between them and his monocle that is both disdainful and respectful. (Disdainful, because it is necessary; respectful, because of the total beauty.)

He loves sober English interiors, where there is only a woman and a painting; a woman and a shade plant; but, cruelly, he prefers to guillotine heads in the noon sun: unreal necks and martyred eyes in harsh, insolent light.

He also has a telescope with which he focuses on the tips of ecstatic pine trees, and he looks out a window to see a well in the patio that is dying of thirst, and a fountain, choking with mossy water.

So, looking downward, he catches the vertigo created by archaeological flights of stairs that fall down like ridges of a waterfall, or by the trunk of a palm tree that keeps rising like the arrow shot by a native archer.

Weston's close-up views of the pyramids, alone, make one feel the weight of the centuries that lies heavily on Teotihuacán.

But, afterward, he relieves us by presenting that Christmas

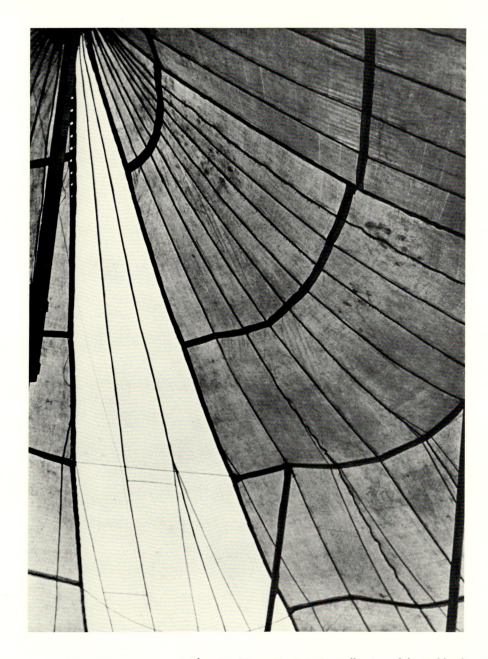

Plate 3 *"Circus Tent."* 1924. Collection of the Oakland Museum, Oakland, California: Lent by Mr. and Mrs. Edward Weston.

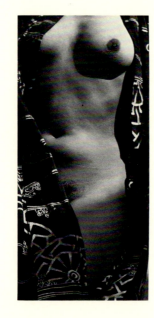

landscape the railroads give away: a wax miniature in the cavity of a nut.

Landscapes. Landscapes.

The naive cubism of adobe houses, cut away unexpectedly by the road, as they must be seen by birds—more fortunate than aviators.

The eloquence of ruins, devastated by the fingernails of time. Expressive admiration for organ cactuses. A cross that dominates the width of that plaza in the town where all the neighbors died. Light that has passed through a sieve of leaves that protect the corner between the basin and fountain. . . .

And women.

The Woman, nude—like in Rouveyre—artificial, painted, and improved.

To see nudes Weston uses an enlarging lens—when not a microscope—and patiently dissects their anatomy with a surgical pleasure.

The flesh of woman—a riddle: where is the face—flesh oppressed from anguish or swollen from pleasure. Isolated breasts that stare at us, looking out of a fan of modest fingers.

The quiet maternity of the hand that wrinkles the silk kimono. The bronze torso, worked and polished like a virginal icon a thousand years old.

Woman nude in the sun: the temptation of the adolescent who looks through a crack at the servant's sunbath. A chaste, partial view of the torso, without sex or age. A perfect triangle, formed by the equidistant points of the breast and center of the stomach. Breasts offered by manicured fingers, breasts, like fruits that will fall when ripe.[88]

On November 1, when Weston took down the exhibition at Aztec Land, he moved ten of his prints to the Palacio de Minería, where he entered them in a fine arts competition sponsored by the Ministry of Public Education. Tina also submitted ten of her prints. Eventually, Weston won first prize in photography, which consisted of 150 pesos, about $75. He was realistic about his victory, however; he realized that there was no effective competition and that, moreover, his friend Diego Rivera was on the jury.

Figure 20 *Tina Modotti, Half-Nude in Kimono.* 1924. San Francisco Museum of Modern Art, Purchase (62.1184).

Plate 4 *"Calle Mayor" or "Pissing Indian," Tepotzotlán.*
1924. University Library, Special Collections, University of California, Santa Cruz.

Although many commercial and pictorial photographers were working in Mexico at this time, they were not concerned with the formal clarity of straight photography, but instead, usually, with narrative and sentimental renditions of traditional and picturesque themes. Moreover, Tina and Edward were the only photographers who associated with and considered themselves colleagues of the muralists—artists who established certain standards for the period and made places for themselves in the history of modern art.

By the second half of 1924, Weston had established himself as a success in Mexico. He had broken away from his studio in California and from an intellectually and aesthetically stifling environment. He had done more work for himself than ever before in his career, he had received acclaim and recognition for it— and the Mexicans had purchased his prints. This had given him confidence and reinforced his conviction that his style of expressing himself photographically had both potential and merit. He was respected not only for his portrait work, for which he had had an international reputation since at least 1916, but also for his photographs of nudes, isolated forms, clouds, landscapes, and still lifes, the last three being themes he had never investigated in any depth or had any real interest in before leaving Los Angeles in August 1923.

TWO
California
January 1925–August 1925

Edward and Chandler Weston took the train back to Los Angeles in the last days of December 1924. Weston realized that he was returning only to see his sons: he was determined to earn enough money to go back to Mexico as soon as possible. He brought with him serapes to sell and juguetes to make himself happy, including a Panchito Villa: "that tough rough-neck, with a faded flower in his horse's bridle, I am afraid any moment that he will turn and shoot up his best friend for bringing him to this land of grey sky, bootleg, and singing evangelists." Weston wrote that he felt like a "stranger," "a foreigner," "a camper" "surrounded by . . . [his] dead past."[1] He also must have realized that his successes in Mexico would be difficult if not impossible to repeat in the United States.

On 3 March 1925 he wrote to Stieglitz:

> . . . returning here to San Francisco to "stage" an exhibit of my
> Mexican work—I have worked with much intensity in Mexico—
> better too—much better—my love and respect for photography
> increases— The Mexicans though poverty stricken bought
> prints to back their appreciation—I hope to return there soon—
> better starve among real people than *this*![2]

Weston opened a studio in San Francisco; people admired his work but did not buy. The redeeming aspect of his return to California was being with his sons and seeing old friends: Johan Hagemeyer; Margrethe Mather; the dancer and editor Ramiel McGehee; the painter and sculptor Peter Krasnow; Miriam

37

Lerner, a member of the Young Socialist League and executive secretary to E. L. Doheny. He probably also saw the photographer Imogen Cunningham and her husband, the printmaker Roi Partridge.

Only scattered notes from Weston's *Daybooks* have survived from the eight months he spent in the United States in 1925 (or perhaps he made only a few entries, which seems to be what occurred when he was either bored or ecstatic).[3] At any rate, his only mentions of portrait sittings appear in his letters to Hagemeyer, which also indicate that he was not involved in much work for himself. In July he wrote Johan from Glendale and his attitude in that letter could be considered fairly characteristic of his entire stay: "—no sittings as yet—partly my own negative state at fault—as it was later on in S.F."[4] Almost ironically, it seems that only once he was back in Mexico did he analyze his photographic accomplishments during this period; only then did they give him any real joy.

In October, for example, he wrote from Mexico to Miriam Lerner, who posed nude for him at least twice during his stay in California and analyzed the results of their collaboration:

> —You may not have realized it but the work I did of you—the nudes—and those of my little boy—Neil—I forget if you saw them—were the start of a new period in my approach and attitude towards photography—you were an ideal person to work with—and too—I felt your beauty so very keenly—and by this I do not mean just the undeniable physical beauty you possess—yet of the latter I speak and insist that now I have not the same enthusiasm to go on in the direction started with you—perhaps I shall turn for solace to the clouds again—or the Mexican juguetes (toys)![5]

He did not discontinue this direction as he thought he would, but he elaborated upon it. Six months later, he described his progress in a letter to Miriam: "[I have made] nudes too that are the best I have done, so far as simplified form is concerned. They are the logical progressions from those I made of you, and strange coincidence, of a Jewish girl—Anita Brenner [Plate 5]—"[6]

Not only are the forms in these photographs of Miriam extremely simplified, but they are also set against backgrounds that are not distracting. Weston had overcome any inhibitions about violating the physical space separating him

from his model. Never before had he so systematically amputated or isolated any one unconventional section of the human anatomy, beautiful as it might have been. Foreshadowing these pictures, of course, are the extremely spontaneous and timeless portrait heads which he made almost exclusively of fairly close friends, such as Ricardo Gómez Robelo, Xavier Guerrero, Lupe Marín, Manuel Hernández Galván, and Rose Covarrubias, beginning in 1921. He would refer to this style later as his "'faces and postures' period, my heroics of social significance. . . ."[7] Even though Weston was being a little sarcastic, it would be appropriate to call these nudes "heroic," because of their larger than life proportions and because of the simplicity, strength, and nobility they convey.

The three photographs of industrial plants that he probably took around Glendale in July or August 1925 are an extension of this heroic style. Although he began working with this type of subject matter at Armco in 1922, his way of seeing changed considerably after his first trip to Mexico. No longer did he approach factories like a spectator or a tourist, in awe, perhaps even asking permission beforehand. Instead he moved in and isolated simple, compact, pristinely clear details in his compositions. Even though these photographs suggest that he may finally have been adapting to the consequences of industrialization in the United States, he was still anxious to return to Mexico from his self-imposed exile.

Only thirty-three photographs have been located from his eight months in California in 1925, and twenty-six of these were probably taken on five or six occasions; he was not accustomed to such low productivity.

Edward and his second son Brett sailed for Mexico on August 20.

Figure 21 *"Tronco de Palma."* 1925. Collection of Zohmah Charlot, Honolulu, Hawaii.

THREE

Mexico
August 1925–December 1926

> Yes, here I am, for better or worse in Mexico again. Something here was strong enough to return me, the natives? the tierra? or was it a desire to escape from conditions I could not endure?[1]

Edward and Brett took the train from the port of Manzanillo, where they had disembarked, to Colima and then to Guadalajara where, probably on August 27, they met Tina. A ten-day exhibition of their work had been arranged at the State Museum. He noted that each day we "grew more irritable and despondent. . . ."[2] The only prints sold were six by Edward which Governor Zuno purchased for the Museum. He was, however, well received by the local newspapers: "Weston, the Emperor of Photography, Notwithstanding His Birth in North America, Has a Latin Soul."[3]

In reviewing their show for *El Informador*, the painter David Alfaro Siqueiros called their work "THE PUREST PHOTOGRAPHIC EXPRESSION." He praised the simplicity and straightforwardness it revealed: things that were rough appeared rough; stone seemed hard; flesh seemed to palpitate; objects revealed their weight, size, and location in space. Possibly influenced by the estridentistas, Siqueiros attributed this approach to their understanding and appreciation of industrial photography. Finally, to consummate his review, he noted that their photography could be admired as an art form in itself, that is, for its own beauty.[4]

Weston summed up the experience: "We put on the show in Guadalajara—a financial failure—an artistic success!"[5] Never before in his career had

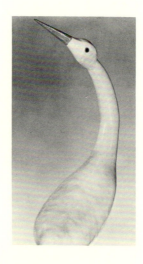

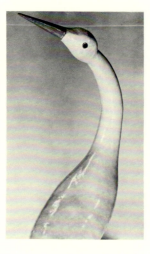

Figure 22 *"Pájaro Blanco."* 1926. Collection of the Oakland Museum, Oakland, California: Gift of the Oakland Museum Association. Figure 23 *"White Heron."* 1926. Collection of the California Museum of Photography, University of California, Riverside: Extended Loan from Hardie C. Setzer.

he received such lengthy and thoughtful praise in the press from someone of Siqueiros's stature.

The show closed on September 6; on September 9 they took the direct train to Mexico City.[6] By September 14 Weston was back in his darkroom in Mexico City, sitting on his hypo barrel, contemplating the recent past and the inevitable future. Despite thirty-five printed pages in the *Daybooks* and some correspondence, little is know about his photographic activities until after 3 June 1926, when Tina, Brett, and he left on the trip which would take them from Oaxaca to Guadalajara. Since three impressive articles were published about him and his work in Mexican magazines of wide circulation during this period,[7] there can be no question that his reputation as a photographer was growing. He still made his living by doing portraiture, but he mentioned it even less frequently than before in his journals and correspondence. Other than the show in Guadalajara, no record has been found of any other exhibitions in Mexico or abroad in which he participated during his second stay in Mexico.

In this nine-month period we know about only four projects upon which he worked: the toilet (Fig. 24) and sink, Anita Brenner's back, the *juguetes*, and the pulquerías. Basically, they all consist of still lifes. Simplified form is of utmost consideration in each case, and probably never before in his career had he so persistently worked on a single theme other than portraiture.

On October 21 he used the phrase "form follows function" in his *Daybooks*[8] and he began photographing his toilet. He did not let either technical or compositional problems get the best of him, nor the sincere praise of his friends. He previsualized what he sought to register. At times, he tried to convince himself that he had obtained exactly what he desired. In the two weeks he spent on this project, he moved back and forth repeatedly from the bathroom floor to the darkroom and to the company of his friends. The muralists Jean Charlot and Paul O'Higgins told him that it was one of his "most sensitively observed" works. Diego commented: "In all my life I have not seen such a beautiful photograph."[9] But Weston was not satisfied and returned again and again to the bathroom; finally, on November 4, he settled on a photograph that still disturbed him somewhat because of the presence of the wooden toilet seat. The toilet project might well be considered the maturing of his fascination for still life, which is more frequently associated with sea shells and green peppers. He had been

deeply moved by the unassuming, simple, functional form of the toilet, with its flowing masses and its shiny surface; perhaps he was also attracted to it because it was a fairly universal product of the Industrial Revolution that had been consistently ignored.

Exactly a week after he completed the project in the bathroom, Anita Brenner, a good friend of Charlot's, walked into Weston's studio for an appointment to have nude photographs of herself made. It was early in the morning; he was still shaving; the weather was cold and rainy. He did not feel inclined toward this sort of work, and he wanted to postpone it. Paying no attention to his feelings, she disrobed and began posing. Weston was startled not by the traditional components of nude photography, such as the breasts, legs, or thighs, but by the flowing, toilet-like form of her headless back: "And then appeared to me the most exquisite lines, forms, volumes—. . . ." Using his Graflex, he quickly made fifteen negatives of her. He later noted that he might finish eight of them, surely six. Twelve different views have survived. Two days after this sitting, he commented: "they retain their importance as my finest set of nudes—that is, in their approach to aesthetically stimulating form." About a week later he added that they had ". . . caused more comment than any work I have done." [10]

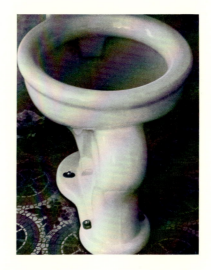

Weston was still not satisfied, however. He could not redo the pictures because Anita had been in an accident the day after the sitting, and he knew that he would have to eliminate the background when he printed them, which of course, was what he had done three years before when he made the portrait of Xavier Guerrero. But he also observed that:

> A's body as the camera sees it, is mottled and blotched. The nudes I did of her, required a skin quality of exceeding smoothness, otherwise,—and this happened, the eye is disconcerted from full pleasure in the enjoyment to their fundamental offering,—form.[11]

He made the necessary corrections while printing and he continued to work toward the perfect negative. Simultaneously he recognized: "And most important I have worked better than ever before, stronger, more direct, more genuine." [12]

Almost immediately upon his return to Mexico, he began collecting *juguetes* again: "a crimson spotted dog, a leopard, a couple of viejitos [old people],

Figure 24 *"Excusado" from Above.* 1925. Instituto Nacional de Bellas Artes: Museo de Arte Moderno, Mexico City: Gift from Manuel Alvarez Bravo.

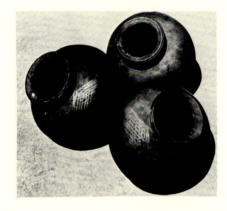

and pigs with bursting bellies." In the next six months he worked frequently with all sorts of artifacts, from rag dolls to monkeys, from a cherub to a vampire, with different kinds of birds, including a penguin and a "spectral white bird," and, of course with the three black pots from Oaxaca.[13]

The photograph that stylistically follows most logically in sequence after those of the toilet and Anita Brenner's back depicts three globular black clay pots from Oaxaca. He composed and shot the picture on the roof of his house. With their open mouths and round bodies, the three pots seem to be studies in primeval form. Each pot is in focus in the picture, but the textured surface of the roof, like the sky in a landscape, becomes slightly lighter and lighter as it rises; it is in focus only in the foreground. The noon sunlight caused the pots to cast ephemeral, crescent-shaped shadows, practically continuations of the objects themselves, which simultaneously provide bases for the pots like the black disks placed beneath oriental vases. This composition could have been static, but the gradations and variations in the intensity of the light shining on the pots give life to them, each one a piece of fruit at a different stage of maturity.

This photograph conveys strong time- and place-denying qualities. The theme, three balls, is such a simple one, and so many variants on it—crystal spheres, flower vases, and fish bowls—have been seen in pictorial photography, that it is both one of Weston's most daring and his most classic compositions. By emphasizing the subtle tonal and textural changes and taking a direct approach to his subject matter he has converted it into an entirely new theme.

Although this composition appears spontaneous and unlabored, it was not a one-shot affair. Weston began working on it February 22 and may finally have obtained a negative to his satisfaction a month later. In November he wrote: "—of all my work maybe [it is] my present favorite."[14]

On June 1 he went with Diego Rivera and Frances Toor, editor of the magazine *Mexican Folkways*, to make photographs of the facades of pulquerías, whose names he had been collecting since his arrival almost three years earlier. The pictures were intended to illustrate an article by Diego on Mexican popular art for Frances's magazine.[15] Weston was as moved by the paintings themselves as he had been before; now he commented:

> The aspiring young painters of Mexico should study the unaspiring
> paintings—popular themes—popular art—which adorns the

Figure 25 *"Tres Ollas de Oaxaca."* 1926. Courtesy of the Weston Gallery, Carmel, California.

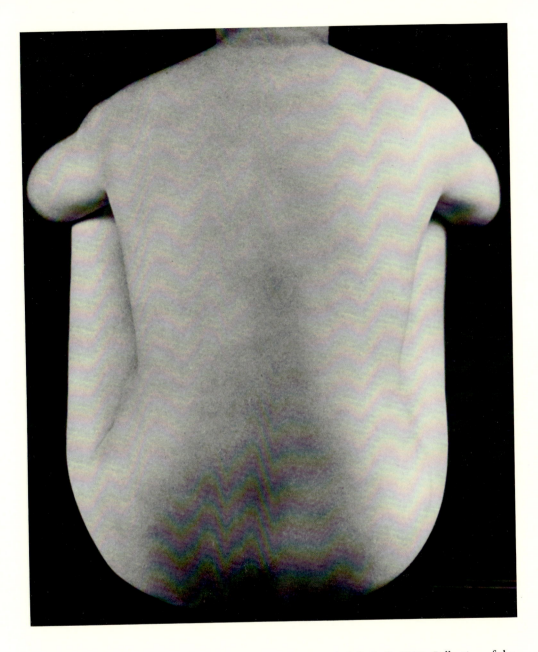

Plate 5 *"Anita," Nude Back, II.* 1925. Collection of the
Krannert Art Musuem, University of Illinois, Cham-
paign, Illinois.

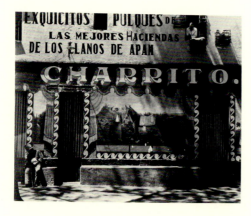

Figure 26 *"Charrito" (Pulquería).* 1926. San Francisco Museum of Modern Art, Extended Anonymous Loan.
Figure 27 *Two Children in Front of a Landscape (Pulquería).* 1926. San Francisco Museum of Modern Art, Extended Anonymous Loan.

humble and often—most often—filthy pulquería. This he should do, instead of going to the degraded impotent art of the self-glorified academician.

I photographed brave matadors at the kill—white veiled ladies, pensive beside moonlit waters—an exquisitely tender group of Indians,—Diego himself could not have done better—and all the pictured thoughts, nearest and dearest to the heart of the people.[16]

That fall he also took pictures of pulquerías for Anita Brenner.

Much later, in 1939, Weston stated that he had only printed two of the pulquerías for himself, ever.[17] These would have to be *"El Charrito"* and *"Calle de Rayon."* In 1943 he published one more, a mural of a landscape with two children in front of it. All in all, ten photographs of pulquerías were recorded in his "Log." Finally, five were included in the Project Prints, the two new ones being bullfight scenes. Three of the five pictures are characterized by the fact that people belonging in the neighborhood were included in the composition, an extremely rare element for a photograph by Weston that is not a nude or a portrait. In *"El Charrito"* an old man sleeps on a bench and another leans out an upper-story window to take care of his bird cages; both seem to be unaware of the photographer. In *Bullfighter and Boy*, the receding street and power poles are included, as well as the blurred image of the top half of the head of a boy walking toward the photographer. Another picture shows two children, standing in front of a painting of a landscape, giggling, delighted that they are to be recorded also. On the other hand, in *"Calle de Rayon"* the surface of the wall has been so mutilated by natural forces that a living, organic surface has been created. In these five, in particular, Weston emphasized spatial recession, projections, ambiguities, and contradictions. Possibly this was done to demonstrate that the subjects were dynamic and located in a living ambient, and maybe also to create a certain slightly alogical visual staccato. Such intentions, of course, recall Charlot's offer "to work out the geometrical plans" of some of Weston's photographs, because this aspect of them had been questioned, and to him they seemed "so exact as to appear calculated." Weston responded by saying, "No, Jean, to stop and calculate would be to lose most of them."[18]

By the way Weston organized the contents of the pulquería photographs, locating them in both space and time, and by accentuating the ephemeral

qualities as well as his personal perspective, he made a visual statement to the effect that by carefully selecting what would be recorded in each composition, he was participating in a creative act—that his prints were works of art, not illustrations.

The four themes on which Weston worked after his return to Mexico in August 1925 all involve still life and, stylistically, indicate that his considerable efforts and concentration in this area were slowly changing his approach to it. In December 1925 he had written:

> it used to be an attempt to introduce life into a preconceived placing of Studio properties,—pictures, pots, what not,—always forced, though I was better than my co-workers in creating these artificialities. Now I am content to take life as I find it.[19]

This is, of course, relative, and Weston is clearly oversimplifying his aspirations about a subject matter to which he would dedicate a significant portion of the rest of his career.

Several times in his *Daybooks* Weston mentioned how greatly he wished to see something outside the capital, to travel in Mexico. On April 17 he wrote:

> There is a possibility that our lives will be full of adventure and new scenes. A proposition from Anita may take us to Michoacán, Jalisco, Oaxaca and other points. I live in this hope, for I hate this city life and would gladly leave for anywhere, even the States.[20]

In less than a week his plans were well formulated; it seems he had been promised a formal, written contract. On May 5, he wrote Anita a letter that was probably intended to force her to follow up on the contract, since there is no reference to another offer:

> Dear Anita,
> I have a new proposition which I must consider if the one we are mutually interested in fails. I have *until* Saturday morning to wire my answer. So if the contract is not signed by then, I must change my plans. It is necessary to act immediately. I either return to the States at once or remain here long enough to do the work we planned together. Hastily—
>
> Edward[21]

Mexico:
August 1925–December 1926

47

The next day, Thursday, he wrote in his *Daybooks*: "I am not going to have the signing of this contract dragged out Mexican style. I have given the officials until Saturday to sign if they wish my services." On Friday he noted: "I want the money in my pocket [from an important order], then I can leave here if the contract is not signed. My decision is quite definite, I only lack money." On Monday, May 10, he remarked:

> My "expedition" is still uncertain, and uncertainty is demoralizing to me. The big order is finished—if not paid for, I will have enough cash to leave, but just enough,—and that is not enough. I want to return via Guadalajara. I want to live there awhile, but how could I earn a living?

Finally, four days later, on May 14, he wrote:

> After an apparent deadlock over terms, the expedition seems assured. With the signing of our contract, we leave for Puebla and Oaxaca next week. This is the opportunity I have awaited three years.[22]

The contract, however, was dated April 29. It was signed by the rector of the National University of Mexico, Alfonso Pruneda, as well as by Anita Brenner and by Edward Weston. The terms of the contract state that by September 1, Weston, working under Anita Brenner's supervision, would turn over to her four copies of not more than 200 photographs, and for this work he would be paid 1,000 pesos, which at that time would have amounted to about $500. The university committed itself to obtain discounted fares on the railroad for Weston and his assistant.[23] Later, however, Weston noted that he had to make 400 satisfactory negatives, not 200. Correspondence and documents indicate that he must have had another job as well, probably also for 1,000 pesos, with the editor of the magazine *Arquitecto*, Alfonso Pallares.[24]

At this time Anita Brenner was twenty-one years old and had published an article on Weston, possibly her only publication.[25] Pallares and she had tentatively agreed to collaborate on a book to be titled *Mexican Decorative Arts*, the text for which had evolved largely from a book-length manuscript Anita had written called "People of the Petate." At one point, Anita and Pallares made a list of 230 photographs from Weston's expedition which they intended to include in their book.

On Sunday, May 30, Weston finally obtained a check for 500 pesos, and by June 3, Tina, Brett, and he had left for the city of Puebla, about eighty-five miles away. On the same day he began photographing objects in one of the two Bello collections. Anita had provided him with a fairly detailed list of monuments he had to shoot. In his journal, Weston wrote:

> . . . —a collection of antiques belonging to Sr. Bello. Rather uninteresting work but many exposures made to count in the necessary total. The four hundred negatives to be done appear at present as a herculean task—for each one must be exceptional in interest, technically fine, and must be finished within a few months, in my own interest as well as Anita's.[26]

His aspirations and expectations of himself were nothing less than heroic, especially if he took into consideration the fact that he probably had not made many more than 400 negatives for himself since he arrived in Mexico in August of 1923.

The question inevitably arises, Exactly what part of the job was done by each member of the expedition? We know that they traveled with three cameras: these must have been Edward's 8-by-10-inch Seneca view camera, his 3¼-by-4¼-inch Graflex, which Brett also used in Mexico, and Tina's Graflex, for which she had traded in her Korona in San Francisco.[27] Brett recalls that he did not make any photographs which were included in this project[28] and that Tina did not contribute to it either. However, there have been attempts to give Tina credit for a substantial part of the photographic work.

In the Acknowledgment prefacing *Idols behind Altars*, the book that eventually evolved out of "Mexican Decorative Arts," Anita Brenner wrote: "The two photographers who shared this commission, Edward Weston and Tina Modotti, are too well known and respected as masters of their craft to expect in *Idols behind Altars* any acknowledgment less than deeply grateful. . . ."[29] About 1965, Anita wrote to David Vestal that: "It was the first time this [a study of Mexican art] was ever done taking into account popular art. Tina did a good deal of the work interchangeably with Edward, so that it would be impossible really to say whose pictures are which. . . ."[30]

Evidence, however, seems to indicate that Anita Brenner did not know who made which picture. It seems she discussed the project only with Edward,

not with either Tina or Brett, and the contract involves only him and an "assistant." In the twenty-eight letters and postcards Edward wrote Anita about the project, he is the only person specifically and repeatedly mentioned as taking photographs. This pattern also occurs in the *Daybooks*.

Edward did, however, acknowledge how important Tina was in locating objects and serving as an intermediary and an interpreter: "Tina is indispensable—she disarms the suspicious—she tells the most convincing lies according to the situation. Brett makes a marvelous cargador [porter]." [31] In the past, Edward had been proud of Tina's photographic accomplishments, and it is strange that, in the materials available, there is no reference to her photographic work on this expedition. Her own letters confirm that she was not always a very productive photographer. [32]

Almost all of the approximately 40,000 photographs in the Brenner Collection are identified on the back, except those from this project. When Tina began photographing works of art after Edward's departure, she stamped them accordingly. Some of the expedition photographs were labeled in Weston's hand, but not signed. Apparently in 1926, Anita noted on a few of them "Foto Edward Weston." She did not ascribe any of them to Tina.

Between 1955 and 1970, when Anita edited and published the magazine *Mexico This Month*, she used some of these photographs from her archive. Only once did she include a picture which she attributed to Tina that must have been taken on this trip; however, there is no example of it in the Brenner Collection. [33] Moreover, in *Mexico This Month*, often Weston was not credited for his photographs. There does not seem to be a correlation between what, if anything, is written on the verso of a print and which photographs were credited to him. [34] In short, the evidence suggests that Tina did not contribute more than a few photographs to the project and that Anita did not know about the specific authorship of the prints from the expedition.

Anita Brenner does not seem to have placed any unusual aesthetic value on Weston's photographs. The originals were often marked for reduction, cropped, and details were covered with opaque white paint. His works were stored, roughly by subject, amidst the thousands of photographs in her archive. Anita Brenner was a writer and, perhaps, to her, the pictures by Weston were merely

illustrations. Many of her own photographs suggest that she was not interested in photography as a form of artistic expression or in the technique itself.

In July 1926, Weston, then on the western leg of his trip, received a message from Pallares about the quality of his photographs. He replied to it in a letter to Anita from Morelia:

> I have not the slightest idea what Pallares means "to vary the tones"—which naturally are fixed by what the subject was—nor can I imagine how to make things "luminous" unless they were so from a technical viewpoint. I am sure the negatives were—as a whole— quite brilliant—some much more than the original subject.
>
> 'Yours for better pictures' E. [35]

Later, Anita informed Edward that she wanted his negatives, although this was not specified in the contract. She could not have appreciated the fact that most photographers are more possessive about their negatives than they are about their children. Edward was offended and refused. His resentment marks the rest of their correspondence.

Idols behind Altars, written by Anita alone, was finally published in 1929. It contains 70 photographs, 69 of which were probably by Weston.[36] Anita had at her disposal at least 200 of his photographs, and possibly 400. Of those she included, at the most only 15 could have given real aesthetic pleasure to Weston, and one of those, "*El Charrito*," has been cropped severely at the top, eliminating a significant part of the subject and of the composition. The other 54 photographs are fine illustrations, copies of masks, murals, *retablos*, and pastel drawings, and constantly remind us that Weston had a contract at his back.

He wrote to Anita on 28 October 1929 thanking her for the copy of the book she had sent him. He commented on the fine printing and said: "it is a privilege . . . to feel that I had a small part in the making." A thank-you note from Tina for her complimentary copy also survives, and there are no suggestions in it that she was responsible for any of the photographs.[37]

The purpose of Weston's letter to Anita while he was on the expedition seems to have been to assure her that he was working, despite enormous obstacles; apparently it rained almost all the way from Oaxaca to Guadalajara, preventing them from exploring and, sometimes, too, keeping the Indians from

coming to market. He wrote: "It rains furiously. . . . Camiones [buses] are not travelling at all—roads washed out or turned into rivers. This is certainly a bad time of year to work in photography."[38] He also explained that his work was seriously impeded by the open conflict that started in the spring of 1926 between the Roman Catholic Church in Mexico and President Calles's government. With centuries of tradition as a precedent, the Church insisted on maintaining a position above and outside the Constitution. Hoping definitively to separate Church and State, President Calles retaliated by enforcing the 1917 Constitution and by expelling foreign priests and closing Catholic primary schools and convents.[39] Finally, on July 31, the clergy went on strike and the churches were taken over by citizens' committees. Since much of the work Weston had to do was around or in churches, he suffered the consequences of this conflict: "the letters from government officials are worse than nothing in the church. Everyone is suspicious these days." "Spies follow us in every church, very amusing but disagreeable."[40] Moreover, passes and money which Anita should have sent were slow to come. The letters of introduction which she had obtained for them were not as impressive as they could have been:

> But listen my dear, I want a certificate with gold seal and pink ribbon and a lot of flourishing writing to show petty officials. Yesterday we almost were arrested by the Jefe of some little village near Etla, our letters were not official enough.[41]

Critical and inconvenient as these situations were, they were not sufficient to abate the joy and excitement which Weston felt in discovering new places, new customs, and new artifacts. From Puebla, which was their first stop, he wrote:

> Getting some great stuff here—really unexpected pieces.
>
> I have worked everyday—found much to do—and could only work mornings on account of rain. . . .
> To give you an idea—have done: a wonderful tile interior— altar of Santo Domingo—pulquería interior—tissue decoration— sarape (not important here)—portraits in tile—wooden stirrups primitive influence—important Talavera ware—several fine re- tablos—several boxes—carved door and detail of tile . . . S.F. Ecatepec . . . set sculpture Indian influence—little church near

Ecatepec—a Christ collection—Santos—embroidery—glassware—primitive stone cross-carved—marvellous court of tile—important feather work Michoacan—old—Bello—figure in ceramic—stone angel fine—sculptured frieze—locks colonial—leather work—one idol from museum—today worked in saddlery. This is not all! However I have not "shot" recklessly.[42]

Many of these photographs which he listed so enthusiastically do not appear in the Brenner Collection, but his accounts suggest that all his negatives were successful.

On the other hand, a few of the most expressive and interesting photographs he made on this trip are never mentioned in his letters or his *Daybooks*; their publication and exhibition records indicate either that the negatives were unusable, and he had only one print, or that he did not appreciate them. For example, there is only one known print of "*Arcos*," which he took in Oaxaca. This is an impressive and fascinating study of tones, textures, and similar but irregular shapes. The manner in which the distinctive form of each arch has been silhouetted against the one behind it suggests a eulogy to handcrafted, nonindustrial architecture. The *Pitcher from Monte Alban* is such a simple arrangement that, at first, it appears to be only a record; closer study reveals the careful placement of the object and its shadow, its almost archaic monumentality, the delicate texture, the wide range of transparent tonal areas, as well as the kinetic relationship between the negative and positive areas. To sum it up, the photographer and the object met on common ground, but neither sacrificed individuality to the other. *Detail of Stone Frieze from Mitla* shows that Weston was capable of giving a sense of life to a symmetrical and geometrical pattern by means of cropping in the camera, illumination, and texture. There is no apparent explanation of why Weston ignored these photographs.

From Puebla, the expedition continued south to Oaxaca.

Oaxaca, city raised from rock,—a mellow, yellow-green rock. After the rain which swept the country afternoons, the glistening rock turned to jade,—one walked on flagstones of jade. . . . And Oaxaca,—rain bathed, sweet and fresh in the morning sun, musical with bird song,—with water playing over cobbled streets, encircled by green mountains, topped by lingering clouds—fulfilled all expectations.[43]

Figure 29 *"Arcos, Oaxaca."* 1926. Collection of the Center for Creative Photography, Tucson, Arizona.

Figure 30 *"Heaped Black Ollas" in the Oaxaca Market.*
1926. San Francisco Museum of Modern Art, Albert
M. Bender Collection, Bequest of Albert M. Bender
(41.2994).

Not only did the geography of Oaxaca delight Weston, but also the artifacts he found in the market: "With my meagre collection of Oaxaca juguetes I envy no one's collection of 'modern' sculpture." "[I] Bought new toys—different from any I've seen." He added: "Oaxaca is the most interesting place we have seen in all Mexico. I have some gorgeous toys!"[44]

Although Weston was definitely enjoying himself and was enchanted with his acquisitions, the work did not come easily. "We have found out that the *best things* we have had to *discover ourselves*. Everyone means well, but they direct us to the usual and superficial things. All information is too vague."[45]

Transportation was a nightmare. "No camiones on account of roads. In Tlacolula we waited over four hours for camion. We can only go on horseback by confining ourselves to a walk, this on account of my big camera, for which we have an extra horse and a boy." Just a few days later, he wrote: "We go off at S. Antonio for Teotitlan in a deluge of rain—not a sign of life—no camiones— Teotitlan five hours away—we simply took the train again as it pulled out. It took seventeen hours to reach Puebla from Oaxaca!"[46]

They returned to Mexico City about July 4. He told Anita that he was developing and asked her to come by. A few days later, he informed her that he had a print from each negative ready and wanted her to select from the objects he had brought back with him so that he could photograph them and possibly others which he now realized were very fine, located in friends' collections in Mexico City.

About July 14, he wrote her again. The brevity, tone, and content of the note suggest that Weston was feeling that she was not sufficiently interested in or appreciative of the job he was doing almost at cost: "I am ready to leave again— Waited to hear from you Sat. & Sun.? Have prints ready—yours and Pallares. Edward"[47]

Approximately 110 photographs were the product of the first month's work. We can account for 41 from Puebla, about 16 from Oaxaca, and perhaps 23 taken in Mexico City from objects purchased en route. Weston still had some 290 photographs to take.

About July 18 they left Mexico City for the western part of their trip. Weston was equally thrilled with this part of his adventure, but his correspon-

dence with Anita was much more telegraphic than before. He wrote mostly postcards, instead of letters.

The first card was sent from Morelia, no more than a day or two after leaving Mexico City, and it read: "Please send at once duplicate instructions excepting of course Morelia. Pocket book stolen—money, keys—instructions—etc. Send to Patzcuaro 'general delivery'. We know what to do here. Edward." The photographs and his *Daybooks* indicate that the only pictures he took in Morelia were of objects in the museum.[48]

They left Morelia for Pátzcuaro on July 22, and a postcard he sent Anita the next day noted that the instructions had not yet arrived. In a letter with the same date, he remarked: "we are quite *crazy* about Pátzcuaro!" "Too bad that it threatens rain—and cold! It is so cold my hands are numb." The same inclement weather accompanied them for their entire trip: "Rain—rain—water flowing over tracks,—spectral mountains opening cuts, red and raw, for the train's passage,—then Pátzcuaro—Michoacán."[49]

Somehow in Pátzcuaro they met René d'Harnoncourt, the six-foot-seven-inch Austrian count who later became director of the Museum of Modern Art in New York City. They were all foreigners. They had friends in common in Mexico City, such as the art collector and dealer Fred Davis, and both René and Edward were interested in popular art. D'Harnoncourt was then a buyer for the Sonora News Company, perhaps the major outlet for folk art in Mexico at that time. However, Weston, who was five foot five, was still a little self-conscious about d'Harnoncourt's company: "Conspicuous enough as new arrivals are in a small city, we were now destined to be heralded far and wide like a circus come to town."[50]

The market was "next to Oaxaca in beauty and interest,"[51] but photographs of it by Weston have not survived. Weston described Pátzcuaro as "picturesque,"[52] but this term was no longer anathema to him. His personal style was by now so forceful that no subject matter that appealed to him could dominate his way of expressing himself.

On the island of Janitzio in Lake Pátzcuaro, Weston took a picture just a few inches from the spot selected by Hugo Brehme, a German pictorial photographer who had been living in Mexico since 1910 (Figs. 31–32). The same

hills are seen across the lake in both compositions. Brehme recorded a quaint and somewhat condescending scene to remind the tourist at home of the peaceful, complacent, and colorful poverty of rural Mexico: dilapidated shacks, spindly trees, and fishermen on the edge of a lake with gentle hills and cotton-puff clouds receding back to the horizon. From the same spot, Weston organized a composition on his ground glass that was divided into three horizontal bands. The lowest of them consists of clearly defined polygonal shapes formed by the cobblestone street and the tiled roofs, visually an extremely busy area, but relieved by the middle register, which consists of blank water, an almost opaque region on his negative. The top third of the composition consists of clearly vignetted hills, backed by storm clouds on the left, merging into radiant ones on the right. This complex study of light and form is an extremely dynamic composition because of the juxtaposition of the geometrical shapes in the foreground and the soft forms in the background, and because of the harsh light on the stones and tiles, the mirrorlike glare on the lake and the modeled light on the hills and in the sky in the background. Three months after he took it, he commented on it:

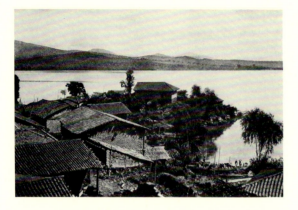

> Both Jean and Diego . . . like a new negative done in Xochi-
> milco of cactus and rock. It yields a hard contrasting print,—in spots
> where the sun reflected from cactus or sand the value is represented
> by almost clear paper, but how else could such eye-blinding portions
> be registered? The same with a lake reflecting the sun, seen above a
> foreground of Indian huts heavily shadowed, which I recorded from
> Xanicho [Janitzio]. The lake is a blank,—quite without detail. I know
> just the people who will criticize these prints. But I know that I saw
> correctly.[53]

Weston is, of course, doing considerably more than "seeing correctly." The scene impressed him; he framed it in a certain manner to emphasize selected tones and forms. He knew what he could make the film record, and he did.

 The two dozen photographs Weston took in the state of Michoacán include an amazing percentage of outstandingly interesting and effective compositions. He took advantage of conditions others might have seen as adverse or impossible. He worked with the wet pavement and the reflecting puddles at the same time that he recorded the bright glare and overcast conditions. He

Figure 31 Hugo Brehme, *"Lake Pátzcuaro, Xanicho Island,"* from *Mexiko Buakunst, Landschaft, Volksleben* (Berlin: Verlag Ernst Wasmuth, 1925), pl. 197. Figure 32 *"Janitzio, Lake Pátzcuaro."* 1926. Collection of the Art Institute of Chicago, Illinois.

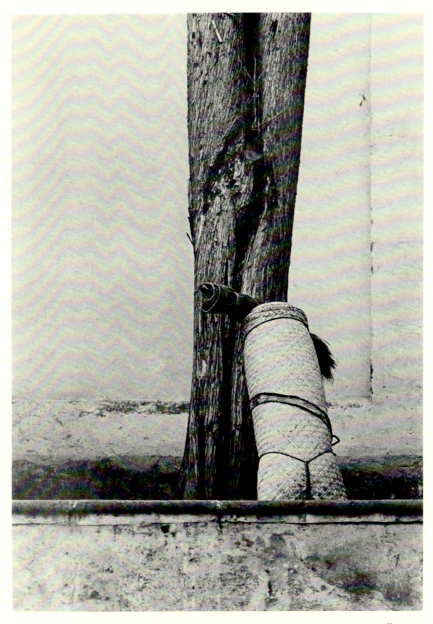

Plate 6 *"Tree and Petate,"* *Pátzcuaro.* 1926. Collection
of the California Museum of Photography, University
of California, Riverside: Extended Loan from Hardie
C. Setzer.

was moved to concentrate on monumental forms and delicate, transparent tones.

He photographed a simple octagonal fountain with a virgin under arches in a small plaza in Pátzcuaro, and he included the simple forms of the adjacent buildings, the detail in the wooden roofs, the puddles and reflections on the stones and steps, and the glare of the rainy sky.

He recorded the nobility and the monumentality of the figures of the virtues on the belltower of the Sanctuary of Nuestra Señora de Guadalupe: he called them "magnificent" and "grandly conceived," with "the strength and fineness of archaic Greek." [54] One of the columnar figures looks out over the roofs of the houses in the town below; and the bright sky silhouetting it creates the same effect that a nimbus would. He emphasized the simplicity of form, the serenity of the sculptural work, and the contrast between the very bright ground and the gentle greys that play on it and define it.

Weston made a picture of a shrine still wet from the rain, accentuating the grayness of the stone, the simplicity and sincerity of the simple painted offering, and the glare of the sky. He also recorded a wheat heart, lovingly woven into a fetish, attached to a cracked adobe wall, with the light illuminating and isolating each spike, and simultaneously creating deep shadows behind it that seem almost mystically to emanate from the same spikes. He idolatrized a majestic copper brasero and created an almost conceptualist image out of a petate bundle leaning against a tree. And how he must have laughed when he was planning and arranging his still life of dancing coyote cookies!

The most amazing aspect of these works from Michoacán is that Weston kept only four or five of them among his favorite works, those which he exhibited and included in publications. Either he grossly underestimated his accomplishments or he could not use the negatives.[55]

Tina, Brett, and Edward went on to Uruapán, a stop not included on their written itinerary, where they searched for lacquerware for themselves. Then, once again, they went to Guadalajara, where Weston photographed sculpture on the exterior of churches, objects in the Regional Museum, Governor Zuno in his charro costume, Zuno's private collection, and his home.

Weston once again went to Tonalá, a small village of ceramicists a few miles from Guadalajara; it was probably on this trip that he made the photograph of

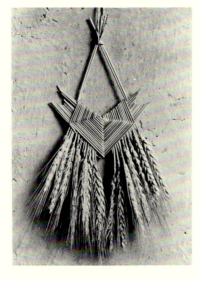

Figure 33 *"Wheat Heart."* 1926. Collection of the California Museum of Photography, University of California, Riverside: Extended Loan from Hardie C. Setzer.

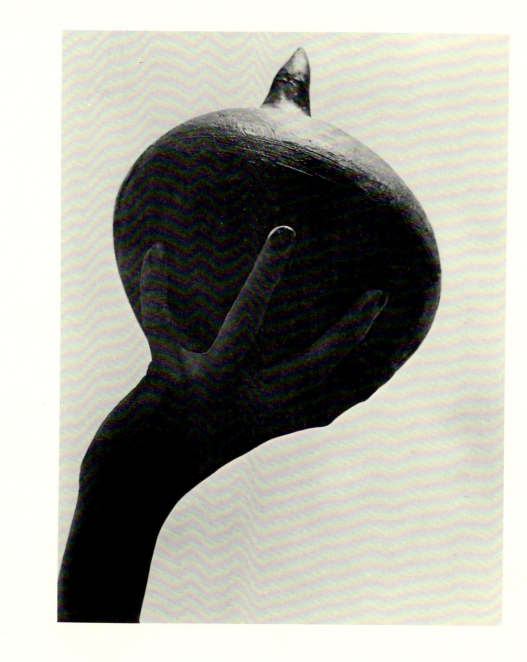

Plate 7 *"Hand of Amado Galván."* 1926. Courtesy of
Stephen White Gallery, Los Angeles.

the hand of the potter Amado Galván. Stylistically this print vividly recalls his work in Pátzcuaro: the delicate separation between the dark tones and textures of the hand of the famous potter and the wet clay of the form he was molding, one growing out of the other, the single form silhouetted against the very slightly mottled, bright overcast sky.

After perhaps twelve days in Guadalajara, on about August 18, they went east to the mining town of Guanajuato where they spent several days without taking a single photograph. Weston wrote:

> Have done nothing here because we found nothing of more impor-
> tance than that which we already have. In fact there was not much of
> great interest from your viewpoint nor Pallares [*sic*]. . . . It has rained
> almost steadily since we arrived here. So—fortunate there was no
> need to work under impossible conditions.[56]

On about August 22, they proceeded to Querétaro, where Weston seems to have photographed mostly architectural details.

When they returned to Mexico City August 26, the first thing Weston did was account for the different shipments of pottery and *juguetes* from the western trip. He visited with his closest friends, read a few magazines, and criticized the photographs that appeared in them by Zwaska, Moholy-Nagy, and Man Ray.[57] He developed and printed like a zealot and started doing accounts. On September 14, he figured that he still had 140 negatives "to finish" (and to make, incidentally) for Anita. He had already delivered 3 prints from each of 110 negatives from the eastern trip, and 3 from 150 taken on the more recent one. Anita commented that she and Weston had made lists of all the prints. He wrote: "And now I am very anxious to be done."[58]

On Saturday, September 18, Edward and Anita worked at the Preparato-ría, probably taking photographs of murals, which, according to Anita, delighted them both, and later that day, took pictures of works by Goitia. On Monday, he gave her proofs of paintings by Orozco (from the Preparatoría, apparently) and of pictures by Goitia.

Weston does not mention working with or for Anita again until Sunday, October 3, when he went with Jean and Brett to take photographs of the facades of pulquerías for her book. However, Anita noted that on September 20, she started the day by getting paintings and other objects ready for Weston. On

September 22, they worked in the National Museum of Archaeology, History, and Ethnology; he photographed the abstract serpent, the red grasshopper, and the pumpkin. On Saturday, September 25, and Monday, September 27, Anita accompanied Edward to several places in Mexico City to take more pictures: the only ones that have survived, apparently, are of Precolumbian things from Chupícuaro, pasteboard figurines from a church on Dolores Street, and tile decorations from the Casa de la Marquesa de Uluapa. On October 2, she posed for him and three days later, he had already turned the proofs over to her, but these have not been located. Edward had a brief respite when his 8-by-10-inch camera fell to the floor in the museum on October 4 and it had to be sent for repairs. But by October 7 he was back in the museum, taking pictures of lacquerware and jewelry. During the next week he also made photographs of paintings by Carmen Fonserrada and by Goitia, and he turned more prints over to Anita.

Weston's entry in his *Daybooks* for Sunday, October 17, describes only a dinner party that night where he "first discovered M.'s lips, and they were sweet indeed, and her Irish blue eyes were bluer than ever in contrast to her flushed cheeks. We danced and danced and loved and loved—but she would not leave the party—'because of Tina!' How ironical!" [59] On the other hand, Anita wrote down in her journal that she, Brett, and Edward had worked that day at Xochimilco. First, Edward had taken photographs of interiors; afterward, the Indian boatman's mother had asked them to make a picture of her husband, who was old and sick. Anita commented that he was seated on a petate, wrapped in a blanket with one hand out, like the figures in the codices. They then went to Goitia's, who was waiting with two attractive native girls dressed in regional costumes (Plate 10). Weston photographed them and also details of Goitia's patio, rocks and succulents, doves and ducks. The omission of any mention of this trip in the *Daybooks* indicates that Edward considered it less memorable than the dinner party that night and suggests he may have felt that it was just a job, not interesting enough to be recorded, like most of his portrait commissions and the museum work.

By September 30, he had written: "I am so 'fed up' on this work I am doing. I go to bed thinking negatives, prints, failures, successes, how many done, how many to do—and awaken with the same thoughts." On October 6, he had

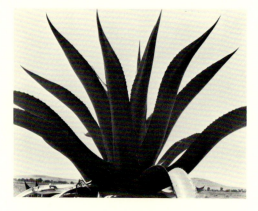

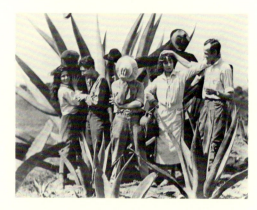

Figure 34 *"Maguey, Texcoco," without Clouds.* 1926. Collection of Manuel Alvarez Bravo, Mexico City. Figure 35 Unknown Photographer, *Tina Modotti, Rafael Sala, Edward Weston, Monna Alfau, and Felipe Teixidor in Front of a Maguey Plant.* 1926 (?). Private Collection.

forty-five more negatives left to make and they wanted him to return to Querétaro. He wrote: "I balk. I have worked hard enough for the money. Working here I could finish in two weeks, print a few platinums for myself,—then leave."[60] By October 30, he still had ten more to make.

Probably on October 18, he rented a car and went to San Augustín Acolmán and Texcoco to photograph church architecture and murals; he exposed seven negatives, including "*Maguey, Texcoco*," the photograph of which was a success in Mexico. He left at least two palladium prints of it there, neither of which shows the clouds that appear in later versions.

Two days later, on October 20, he noted that he had only five more negatives to make: "My herculean task [is] nearing the end."[61] On that same day, perhaps because photographing the maguey plant had made him feel once again the joy of working for himself, he went early in the morning to a tenement house, a *casa de vecindad.* He had visited it the evening before with Goitia and Anita. He described what it was that impressed him there:

> [a] wall of washing hung from a cobweb of ropes. . . . the collective noise of cats and dogs, children laughing and crying, women gabbling and vendors calling. A great opportunity to do something for myself,—this maze of ropes and festooned washing, the zigzag of the cement community washtubs—but the life?—how could I render that and retain definition, minute detail of objects near and far, all fascinating and necessary?[62]

He made eight negatives and commented that one or two might eventually join his collection. Five different prints have survived; the one he chose in the 1950s to be issued as a Project Print was that in which the forms were the simplest, the composition the clearest, and the human figures the least conspicuous. By confronting all five of them, one can see the subtle and significant ways he moved his camera and the patience he displayed waiting for the sun to rise, the shadows to diminish in size, and the light to become stronger—and how important all these elements were to him.

A week later he was still trying to finish the commission. He took three negatives of colonial architecture and Aztec sculpture. According to his notes, this left him with one more negative to make, "a painting by Goitia to be copied, then I am free! I am quite gay and carefree to be through." By November 3, he

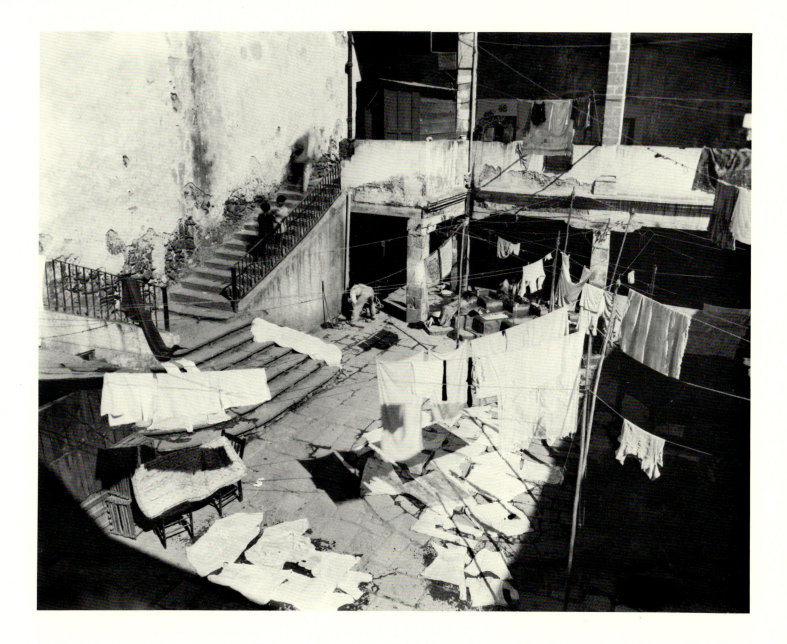

Plate 8 *"Casa de Vecindad," II.* 1926. Collection of the
Center for Creative Photography, Tucson, Arizona.

had finished the work for Pallares and he had printed "the last negatives and Xtra Orozco—which completes the work—all but one of Goitia which I will do if you get it to me by 9:00 Monday [November 7]."[63]

It had not been an easy task to get paid. There had been delay and inconvenience caused by a check that did not reach Guadalajara on time, and then Pallares did not have the funds to pay him when the work was done, as he had promised:

> Well, here I am until the 1st of November, at least—and through no fault of mine. Sr. Pallares cannot pay me the balance due of seven hundred fifty pesos before this date. I was furious—having more than fulfilled my end of the bargain—and to stay on here means extra rent—expenses I had not counted on.[64]

Moreover, it meant that Weston could not make his reservations until he had received the money. And Pallares did not pay him on November 1 either. Finally, three days later, he paid, although forty pesos less than the sum agreed upon.

On November 6, Anita wrote in her journal that Weston was finished.

After some time had passed, Weston compared his work for Anita with a commission undertaken by a friend:

> After the months of heartbreaking work, mental strain and physical effort, he will receive exactly what he spent out in cash expenditures,—$1000. Nothing for his ability as an artist, not a red cent for his time as a day labourer. But he knew what he was going into, as I knew when accepting the commission to illustrate Anita's book on Mexico. Neither he nor I can complain, yet we were exploited.[65]

What may have been the most disheartening part of working for Anita was that it seems she was not excited by the images that excited Weston. For example, he was thrilled when he found and photographed: "—strong hieroglyphics imbedded in a wall,—and a painting on another wall, standing alone amidst fallen arches," and "a wonderful tile interior," and a "marvellous court of tile."[66] But these photographs do not appear in Anita's collection today, which seems to be almost complete. Anita might have been satisfied with any photographer capable of making reproductions of the works she stipulated. Her choice of Weston was serendipitous and there are no indications that she ever appreciated her good fortune.

This relationship, however, may well have affected the rest of Weston's career. He had been determined that each of the 400 prints would be "exceptional in interest, [and] technically fine."[67] It was the first contract of this magnitude that he had accepted, a commission in which the number of prints, the subject matter, and the due date were stipulated—and it would also be his last. When he worked for the Public Works of Art Project of Southern California during the depression he was paid to do anything he wanted, with few exceptions. In 1937, when he was funded by the Guggenheim Foundation, he produced about the same number of negatives each month that he had on the expedition in Mexico,[68] but he photographed what he wanted, where he wanted, when he wanted, and if he had wanted, he could just as well have stayed home, which he did, in fact, when he had the grant renewed. When he accepted the *Leaves of Grass* commission, no one pretended to stipulate exactly what he should photograph.

The job for Anita Brenner proved beyond doubt that, despite discouraging conditions, Edward Weston possessed astonishing tenacity and patience, as well as an almost masochistic sense of responsibility and honor for having signed the contract. Some of the subjects which Anita assigned him were straight copy work, such as reproducing easel paintings, murals, and pastel drawings. Others, such as the pulquerías, fell in an intermediate zone; since the subjects were not considered a traditional art form and a convention for reproducing them had not been established, Weston could work more freely. For almost anyone but Weston, the overwhelming majority of the rest of them would also have fallen into the realm of copy work, especially those involving relief sculpture. Although a few of these are less successful than others, the rate at which he created exciting works of art out of objects most photographers would have considered unworthy of reproduction must be unsurpassed. A reasonably accurate estimate can be made of the number of negatives actually exposed on the expedition, and it shows that there was almost no waste or duplication.

Because of his sympathy and respect for the people who created these objects, and his awareness that the artifacts represented their creators, he was capable of portraying them with the same affection with which he had captured his own children fifteen years earlier. For example, he worked on a subject which from a thematic point of view could only be considered pedestrian, a subject not

necessarily avoided by other photographers, but one that never occurred to them: a pair of sandals and a sombrero. Admittedly, the content might be considered interesting from an anthropological or an ethnological standpoint, but, in his composition, Weston did not include any clues about the owner of these items, the way they were used, or even any indication that there might be a story about them. He approached them and appreciated them as objects formed by artisans who cared about the design and quality of their work. He did not conceal their imperfections, their nonindustrial qualities, but, for instance, showed the dent on the left side of the hat. At a hurried glance, the composition might appear to be symmetrical. Close observation, however, shows that the hat is slightly closer to the sandal on the left than to that on the right; that the two shoes were not placed at quite the same angle; and that the hat is slightly closer to the left edge of the composition than to the right one. Moreover, it becomes clear that Weston did not select just any section of adobe wall for a background, but specifically chose this one, partly because of the way the bump in the imperfect, unfinished paint job on the back wall mimics the circular outline of the rim of the hat, just as the cracks emphasize the vectors in the composition itself. Initially, the picture appears flat and uninteresting; only gradually does it become clear that Weston is playing sophisticated games with space, that an actual spatial reconstruction of the still life may be impossible: if the hat is leaning against a vertical wall, and the shoes are on a horizontal plane, as the changes in the surface texture and view point would suggest, where is the corner joint separating the two planes? If the composition was photographed from above, the sandals are at an impossible angle. The deceptive impression of flatness is accentuated by the uniform, caressing precision with which detail and texture have been recorded; not a stitch in the sandals, not a single intersection in the weave of the hat, and not a protuberance in the impasto of the adobe wall has been sacrificed to a shallow depth of field. The illumination falls on the objects from the left so that the dome of the hat and its rim throw transparent shadows, emphasizing the volume and texture of the form and of the background. The sandal on the left casts a deep shadow, separating it distinctly from the hat, and differentiating its role in the composition from that played by the shoe on the right, the shadow of which can barely be discerned. This print contains examples of each of the ten zones in the zone system, a method for obtaining more precise control over

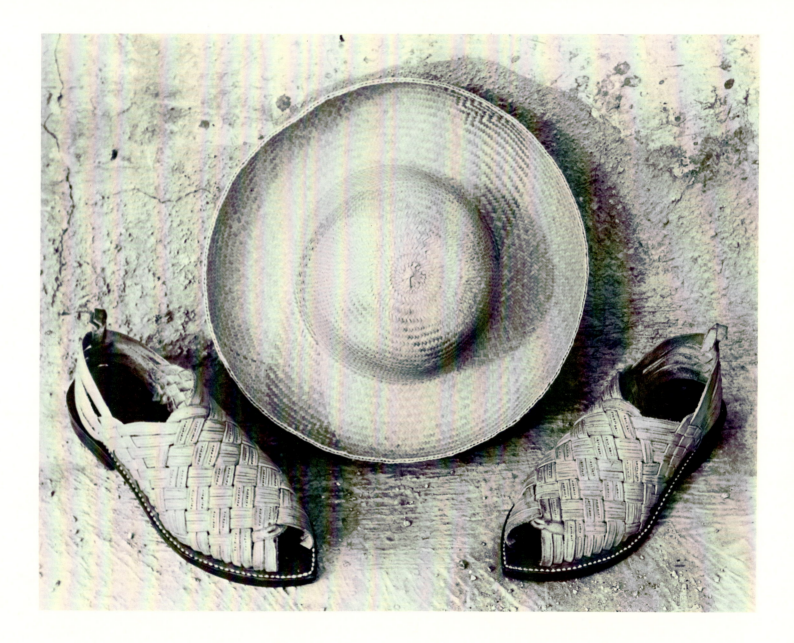

Plate 9 *"Hat and Shoes."* 1926. Collection of the California Museum of Photography, University of California, Riverside: Extended Loan from Hardie C. Setzer.

exposure by defining ten steps from white to black, like notes on a scale. The transitions between them, however, are so subtle that students of the system might find it confusing.

Weston has allowed the objects to maintain their identity, their individual styles, but he has met them with a style of his own, and a balance has been achieved in which neither dominates or exploits the other. In other words, he respected his own identity and personality as well as those of the objects and of their anonymous creators. Weston never conveyed this sense of serenity and acceptance in his work before he went to Mexico.

Years later, he would try to articulate these feelings:

> Anything that excites me, for any reason, I will photograph: not searching for unusual subject matter, but making the commonplace unusual, nor indulging in extraordinary technique to attract attention. Work only when desire to the point of necessity impels,—then do it honestly.
>
> Life rhythms felt in no matter what become symbols of the whole.[69]

In a conversation with the artist Walt Kuhn, Weston said: "Once my aim was to interpret a mood, now, to present the thing itself." Astutely, Kuhn replied: "You only think you 'present.'" Somewhat less metaphysically, Weston also described his personal creative process as: "giving and receiving—of equal import whether in sex or art."[70]

While in Mexico, Weston made only a few observations that pertained to the changes taking place in his own style and to the direction he was taking. Describing the joy he felt at the market in Oaxaca and the purity and strength of the toys and the ceramics he found there, he wrote: "Very well do these people reproduce, make use of the essential quality of a material,—splendidly do they observe and utilize to advantage the very essence of form."[71] Obviously, what he admired in their work was what he sought in his own.

In September 1926, looking back over his own evolution, he concluded:

> These several years in Mexico have influenced my thought and life. Not so much the contact with my artist friends as the less

direct proximity of a primitive race. Before Mexico I had been sur-
rounded by the usual mass of American burgess—sprinkled with
a few sophisticated friends. Of simple peasant people I knew nothing.
And I have been refreshed by their elemental expression,—I have felt
the soil.[72]

Mexico:
August 1925–December 1926

In Retrospect

When Weston looked back at Mexico from the perspective of Glendale, his enthusiasm may have been affected by the tediousness of his job for Anita Brenner. Whether or not he ever recognized it, though, the pressure of that commission forced him to synthesize, to see more rapidly, to previsualize more accurately, and to obtain what he sought on the first negative. Still somewhat disoriented in January 1927, he noted:

> For 3 months I have focussed my camera but once on subject matter
> for myself. I could blame 3 loves—but no, time could have been
> found. I am not yet a part of my new surroundings, one foot is still in
> Mexico. New surroundings! Too many faded flowers, I should never
> have returned to my past. But the boys brought me back here, and
> here I will stay until I can make some positive, constructive move.[1]

After taking some photographs, nudes, a few days later, he remarked: "Approach similar to those made of A. [Anita] in Mexico. Repeating my successes? No, I have always felt that I could go on with variations."[2]

Then, in March 1932, he looked back and analyzed his Mexican work once again, but in the light of the stylistic changes that had taken place in his photography since he left Mexico five years before:

> Also they [stills from Eisenstein's film on Mexico] were picturesque to
> a degree, —a fault which permeated my first work there. I admit my
> failure in Mexico,—not complete, I have some strong records,—but

71

as a whole I now realize how much more profoundly I could have seen. Of course I am a different person now! I can blame three things, conditions, for my failure in Mexico: immaturity, psychic distress, and economic pressure. The latter condition kept me waiting in the studio for work which seldom came. It turned me to photographing toys, —juguetes, which have their place, still live: but I should have had more chance to go out.[3]

It is not surprising that he understated his achievements in Mexico, since one of the forces that propels artists is the conviction that their last work is or their next work will be their best.[4]

Weston, however, tended to divorce himself from his Mexican period without giving it due credit. For example, in 1928 four pages in the Mexican art magazine *Forma* were dedicated to his work and four photographs were reproduced.[5] On the first two pages, F. Monterde García Icazbalceta's review of Weston's 1924 Aztec Land exhibition was reprinted.[6] The third page of the article, written by Weston himself, is titled "Conceptos del Artista" (Concepts of the Artist), and consists of five lengthy, one-sentence paragraphs in which he expressed a few of his opinions on photography. The editor of *Forma*, Gabriel Fernández Ledesma, said that he had obtained the material for this article from Weston when he was still in Mexico, as the choice of photographs indicates, and that he never had any contact with him after he left.[7] If this is true, these are ideas which Weston wrote down before the end of 1926:

> I have recorded the quintessence of the object or the element in front of the lens, without subterfuge or evasive acts, either technically or spiritually—instead of offering an interpretation, or a superficial or passing impression of it.

> Photography is not worth anything when it imitates another medium of expression, when it avails itself of technical tricks or foreign points of view.

> Incoherent emotionalism must be replaced by serene contemplation; tricky dexterity must give way to honesty.

> Photography has weakened itself by abusing anaemic impressionism, that is, skepticism, which gives more importance to what is noted casually than what is known positively.

> Photography will take its place among the creative arts only when it is accompanied by sincerity of intent and by a solid understanding of the most subtle possibilities of this expressive medium.[8]

Some of these same concepts, however, are not articulated clearly in his *Daybooks* and other writings until 1929 and 1930, and for that reason they are traditionally associated with the work that he was doing at that time, especially his still lifes of vegetables, shells, and rocks. It is not merely a case of having finally digested the concepts, but he must have had a copy of the 1926 statement he gave Fernández Ledesma and reworked certain word groups. For example, in 1929, the first paragraph was translated into:

> To see the *Thing Itself* is essential: the quintessence revealed direct without the fog of impressionism,—the casual noting of a superficial phase, or transitory mood.[9]

The essence of it appears again in the introduction that he wrote for the works of the West Coast photographers at the Film und Foto exhibition in Stuttgart in 1929:

> Nothing can be transmitted to another, unless an original problem has been felt, conceived and solved: not a trivial problem of clever decoration or personal ego, but the recording of the very quintessence and interdependence of all life.[10]

In the same article, he reworked the third paragraph into: "Opposing this facile approach is photography free from technical tricks and incoherent emotionalism." The fourth paragraph provided more meat for his Stuttgart article, the opening sentence of which was "Photography in America is in a sadly anaemic condition. . . ." In that statement he finally explained what he meant by skepticism and impressionism: "Impressionism is skepticism, it puts what one casually notices above what one positively knows."

The comparison of these statements written by Weston in 1926 (or earlier) and three or four years later shows that he was aware of the fact that he was basically revising and fine-tuning what he had begun in Mexico. For example, in his photograph of a woman seated on a petate (Plate 10), Weston recorded a radical position for the model: her back faces the camera; her face and skin are hidden. There is no question that, for him, she was an inanimate object. Although she

was probably being used to model a regional costume, she and her surroundings became the subject of a still life. Her exact position in relation to the edges of the petate and the petate's placement on the tiled floor were meticulously considered; the balance and arrangement of tones is no more accidental than are the folds of her skirt, which radiate like the ridges on a cabbage leaf, or the gills on a toadstool, or the quills of a pelican's wing. He arranged and balanced the forms, he respected the materials and their organic integrity, and he controlled the illumination to give life to his forms much as he did in his photographs of his toilet in 1925, and as he would in his arrangements of shells and peppers in 1927. Clearly, the words he used to articulate his dislikes, his aspirations, and his values in photography were as appropriate in 1929 as they had been in 1926.

In 1931, when Weston looked back on his stay in Mexico, he insisted adamantly that it had not been an "escape."[11] The irresponsibility connoted in this word, in fact, has little to do with his activities in those years. On the contrary, Mexico may have been a "release." It was the first time since he married in 1909 that he achieved any sort of self-actualization, owing to the fact that, instead of working to support his children and augment his own fame, he was finally dedicating himself to self-expression. In Mexico his approach to photography changed so radically that if documentation on his career were as scarce as much of that on medieval artists, surely, and justifiably, art historians would be studying two separate photographers, Edward Weston the Elder and Edward Weston the Younger.

As he sailed away from Los Angeles and into Mexican waters, interests that he may have repressed in order to succeed as a commercial portrait photographer could no longer be subdued, but escaped in the form of his fascination with photographing clouds. Soon he would also be deeply involved in landscapes and still lifes. These subjects, with which he had almost never worked before, would form the basis of the remainder of his career. His personal vision became clearer, he learned to isolate the subject more readily, and he commented: "Go to Mexico, and there one finds an even greater drama, values more intense,—black and white, cutting contrasts, am I theatrical because I see important forms importantly?"[12]

He felt great sympathy for his subjects. Although he almost never chose to photograph the people on the street or the campesinos, he recorded their

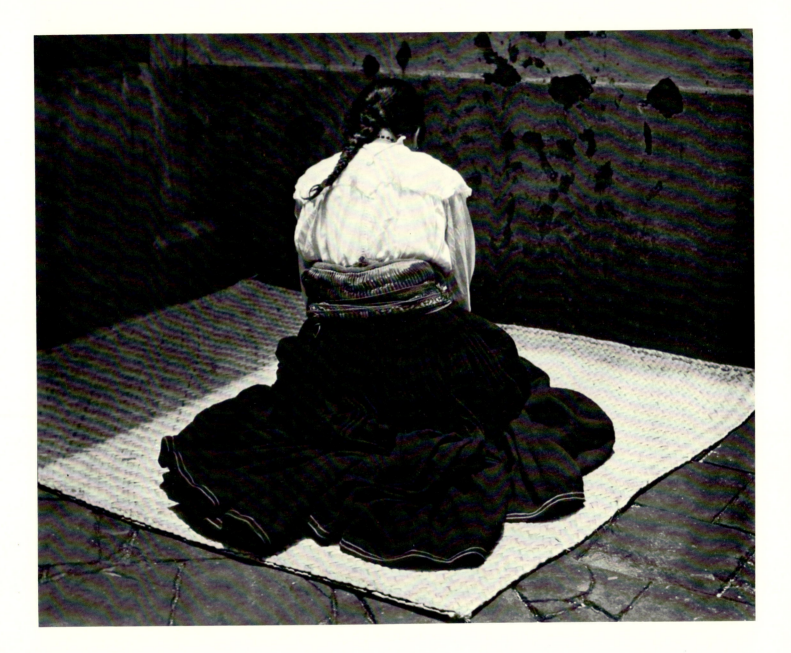

Plate 10 *Woman Seated on a Petate*. 1926. Collection of
the Center for Creative Photography, Tucson, Arizona.

creations, in the forms of toys, pottery, and petates, for him, seemingly, a fresher and more representative theme than the faces of individual men and women. In his struggle to avoid the picturesque, he may not have seen models who were unknown to him as stimulating subject matter, since he had been forced to photograph people whom he did not know for so many years during his career as a portrait photographer. There does seem to be a direct relationship between the personal contact with and affection or respect for his sitters and the success of the portraits he made of them.

However, by associating with the people and their craftsmanship, vicariously at least, he felt the land, and their vital connections with it, as opposed, of course, to the assembly-line production of people and things he had known in the United States. He realized he was part of an organic process, one that he came to respect almost ecologically and felt that he could not improve upon. He hoped to present it, not interpret, rearrange, or retouch it, and he wrote: "I have one clear way to give, to justify myself as part of this whole,—through my work." [13]

One other phenomenon became implanted irreversibly in his personality during the years in Mexico. Charlot isolated it when he wrote him that he missed his company and urged him to reply soon: "There are so few people who *live* for art." [14] Weston defined it even more precisely, perhaps unintentionally, when he described a particular Mexican popular artist as: "one who could never do 'Art' for money—he creates because he has to." [15]

Abbreviations Used in the Notes and Bibliography

CCP The Center for Creative Photography, University of Arizona, Tucson, Arizona.

DBI, DBII Edward Weston, *The Daybooks, Volume I. Mexico* and *Volume II. California*, edited and introduced by Nancy Newhall (Millerton, N.Y.: Aperture, 1973).

GEH International Museum of Photography at George Eastman House, Rochester, New York.

W/B Correspondence from Edward Weston to Anita Brenner. This material is the property of the Anita Brenner Collection.

WE Weston Estate, property of the Center for Creative Photography.

W/H Correspondence and miscellaneous notes, most sent by Edward Weston to Johan Hagemeyer. This material is the property of the Center for Creative Photography.

W/N Correspondence and miscellaneous notes between Edward Weston and Nancy and/or Beaumont Newhall. These papers are the property of the Department of Photography, The Museum of Modern Art, New York.

Notes

Preface

1. A. D. Coleman, "Reinventing Photography," in *Light Readings: A Photography Critic's Writings, 1968–1978* (New York: Oxford University Press, 1979), p. 190.

2. DBI, p. 126.

3. Ibid., pp. 49–50.

4. Ibid., p. xiv and W/N, 15 February 1949.

5. Diana E. Edkins, "A Tribute to Nancy Newhall," *Untitled* (1976), no. 10, p. 5.

Chapter 1

1. Edward Weston to Alfred Stieglitz, 28 May 1923, Collection of American Literature, Beinecke Rare Book and Manuscript Library, Yale University. All quotations from Stieglitz correspondence used by permission.

2. "An Artist-Photographer," *Camera* 20 (June 1916): 322–44; "Events of the Month," *Photo-Era* 37 (September 1916): 143–49; Eleventh–Fourteenth Annual Exhibitions of Photography (1916, 1917, 1918, 1920), John Wanamaker Philadelphia; J. H. Anderson, "The London Salon of Photography," *British Journal of Photography* 64 (22 June 1917): 334.

3. DBI, pp. 4–6; Edward Weston, "Weston to Hagemeyer: New York Notes," *Center for Creative Photography* no. 3 (November 1976), pp. 1–12.

4. DBII, p. 130.

5. Weston sent forty-six pages of manuscript to Hagemeyer about his New York trip; nineteen of them discuss meeting Stieglitz (W/H, 11 October and November 1922). Of the seventeen pages of manuscript on this trip for the *Daybooks*, Stieglitz is mentioned on fifteen (DBI, pp. 4–6; photocopy of original MS in Beaumont Newhall Library, Santa Fe, N.M.).

6. There is an earlier mention of moving to Mexico, but it is extremely vague (W/H, 13 February 1922). W/H, n.d. [spring 1922]; see also Rafael Vera de Córdova, "Las fotografías como verdadero arte," *El Universal Ilustrado*, 23 March 1922, pp. 30–31, 55.

7. DBII, p. 110.

8. W/H, n.d. [November or December 1922], 23 March 1923, 28 May 1923; Weston to Stieglitz, 28 May 1923, Beinecke Rare Book and Manuscript Library, Yale University.

9. Weston to Stieglitz, 12 July 1923, Beinecke Rare Book and Manuscript Library, Yale University.

10. DBI, p. 13; interview with Rose Krasnow, 2 February 1980.

11. DBI, p. 14; W/H, n.d. [2–27 August 1923].

12. Roubaix de L'Abrie Richey to Edward Weston, 23 December 1921, WE.

13. Ernest Gruening, "Will Mexico be Recognized?" *Nation* 116 (23 May 1923): 589; idem, *Many Battles* (New York: Liveright, 1973), p. 107.

14. Katherine Anne Porter, "Where Presidents Have No Friends," *Century* 104 (July 1922), p. 380. See Guy Stevens, "An American's Point of View," in *American Policies Abroad: Mexico* (Chicago: University of Chicago Press, 1928), pp. 147–244; Robert Gottlieb and Irene Wolt, *Thinking Big: The Story of the Los Angeles Times, Its Publishers, and Their Influence on Southern California* (New York: G. P. Putnam's Sons, 1977), pp. 166, 168; J. Fred Rippy, "The United States and Mexico, 1910–1927," in *American Policies Abroad: Mexico*, p. 63; Carleton Beals, *Mexico: An Interpretation* (New York: E. W. Huebsch, 1923), pp. 240, 244–45.

15. Gruening, *Many Battles*, pp. 107–8.

16. Katherine Anne Porter, "Mexico," *New York Herald Tribune Books*, 2 November 1924, p. 9.

17. W/H, 13 February 1922; Mildred Constantine, *Tina Modotti, a Fragile Life* (New York: Paddington Press, 1975), p. 55; Ben Maddow, *Edward Weston: Fifty Years* (Boston: New York Graphic Society, An Aperture Book, 1973), p. 47; David Vestal, "Tina's Trajectory," *Infinity* 15 (February 1966): 6.

18. Ernest Gruening, *Mexico and Its Heritage* (New York: Century Co., 1929), pp. 543–44, 548–49; Beals, *Mexico*, p. 117; Gruening, *Many Battles*, p. 110; Paul Hanna, "Mexico—1921: IV. Culture and the Intellectuals," *Nation* 112 (20 April 1921): 585. Beals, *Mexico*, p. 127.

19. An article, misleadingly titled "Modern Tendencies in Mexican Art," was published in 1922 (by Guillermo A. Sherwell in *Bulletin of the Pan American Union* 55 [October 1922]: 327–39), but it actually discusses Europeanized art of that time in Mexico and the author states: "There is really no Mexican school of painting, sculpture, or architecture" (p. 327).

20. Antony Anderson, "Of Art and Artists," *Los Angeles Times*, 12 November 1922 and 26 November 1922; W/H, 2 October 1922.

21. Katherine Anne Porter, *Outline of Mexican Arts and Crafts* (Los Angeles: Young and McCallister, 10 November 1922).

22. Katherine Anne Porter, "Why I Write About Mexico," *Century*, July 1923, reprinted in *The Days Before* (New York: Harcourt, Brace, & Co., 1952), pp. 240–41.

23. DBI, p. 14.

24. Ibid., pp. 20, 19.

25. Ibid., p. 20.

26. In 1927, Weston commented that to buy a drawing by Máximo Pacheco, he would sell his "Picasso dry-point," if necessary (DBII, p. 11); in describing the works of Picasso owned by his father, Brett mentioned "the beautiful line drawings of the early period . . . Horses and nudes, that period" (typescript of an interview by Beaumont Newhall with Brett Weston, 16 July 1969, p. 6). According to Weston, when Diego Rivera looked at his Picasso print in Mexico in 1923, he stated: "I saw Picasso etch that, it was done in December 1908—I don't know why he dated it 1905—at a time when he was in his cubist period—" (DBI, p. 31).

The only print by Picasso before the 1920s with both horses and nudes is the drypoint *The Watering Place*, dated 1905.

27. DBI, p. 19.

28. Ibid., pp. 21–22.

29. If the title of a photograph by Edward Weston is both in italics and between quotation marks, he assigned that titled or referred to it or the subject in that way, or it was given that title at the time it was made. If, however, it is only in italics, the title has been recently assigned to facilitate identification. The year noted indicates the latest date he could have made the negative, not the year the print was made.

30. DBI, pp. 21–22.

31. The show was held at the Dudensing Gallery in March 1923. See "Spanish Paintings," *New York Times*, 11 March 1923, sect. 8, p. 11.

32. Interview with Monna Alfau, 4 October 1980; album of dated snapshots, private collection.

33. DBI, p. 91; DBII, p. 13; DBI, p. 80.

34. Ibid., pp. 79–80, 67.

35. Jean Charlot to Edward Weston, envelope dated 15 August 1927, WE.

36. DBI, p. 63.

37. Luis Mario Schneider, *Estridentismo: una Literatura de la estrategia* (Mexico City: Instituto Nacional de Bellas Artes, 1970), p. 11. All translations are mine unless otherwise noted.

38. German List Arzubide, *Movimiento estridentista* (Jalapa, Veracruz: Ediciones de Horizonte, 1926; reprinted Mexico City: Federación Editorial Mexicana, 1980), p. 81.

39. Carleton Beals, *Mexican Maze* (Philadelphia: J. B. Lippincott Co., 1931), p. 264.

40. I have not been able to locate the original statement, which was probably in English; a Spanish version of it appears in Stefan Baciu, *Surrealismo latinoamericano: preguntas y respuestas* (Valparaiso, Chile: Ediciones Universitarias, 1979), p. 103.

41. Gruening, *Mexico and its Heritage*, p. 652.

42. Katherine Anne Porter, "The Mexican Trinity: Report from Mexico

City, July 1921," *Freeman*, 3 August 1921; reprinted in *The Days Before*, p. 253.

43. Beals, *Mexican Maze*, p. 267.

44. Baciu, pp. 102, 97–98.

45. Ibid., p. 100.

46. DBI, p. 34.

47. Because of the repeated allegations about "reds" and "Communist insurgents" in Mexico at this time, it should be pointed out that the Mexican Revolution preceded the Russian Revolution and that, ironically, the Communist Party in Mexico was founded by foreigners (mainly from the United States). In the 1920s, the Mexican Communist Party consisted of about 500 members, a third of whom were intellectuals. (Donald L. Herman, *The Comintern in Mexico* [Washington, D.C.: Public Affairs Press, 1974], p. 72; Karl M. Schmitt, *Communism in Mexico: A Study in Political Frustration* [Austin: University of Texas Press, 1965], p. 12.)

Bertram Wolfe, one of the founders of the Mexican Communist Party, who was expelled from that country in 1925, described the artists' understanding of Marxism at that time:

> None of the painters ever took the trouble to study the writings of the Marx and Lenin whose names on occasion they invoked. . . . All that Diego ever knew of Marx's writings or of Lenin's, as I had ample occasion to verify, was a little handful of commonplace slogans which had attained wide currency. Even if Diego and his fellow artists had wanted to study Lenin's works, they would not have found the more horrendous and dogmatic part of his doctrine available in Spanish, or French, or English, nor would they have understood its meaning without considerable effort. (Bertram Wolfe, *The Fabulous Life of Diego Rivera* [New York: Stein & Day, 1963], p. 419)

48. Carlos Monsivais, "La cultura mexicana en el siglo xx" in *Contemporary Mexico*, ed. James W. Wilkie, et al. (Berkeley and Los Angeles: University of California Press, 1976), p. 651; Beals, *Mexican Maze*, p. 282.

49. Beals, *Mexican Maze*, p. 282.

50. Tina Modotti to Edward Weston, 7 July 1925, WE.

51. Manuel F. Gamio, *La población del Valle de Teotihuacán*, 4 vols. (Mexico

City: Secretaría de Educación Pública, 1922); Ricardo Gómez Robelo, *El significado esotérico de algunos símbolos nahoas* (Mexico City: Talleres gráficos del Museo Nacional de Arqueología, 1924–25).

52. Adolfo Best-Maugard, *Método de dibujo, tradición, resurgimiento y evolución del arte mexicano* (Mexico City: Secretaría de Educación Pública, 1923).

53. Alma M. Reed, *The Mexican Muralists* (New York: Crown Publishers, 1960), p. 54.

54. Diego Rivera, "From a Mexican Painter's Notebook," trans. Katherine Anne Porter, *Arts* 7 (January 1925): 21.

55. W/H, n.d. [2–27 August 1923].

56. DBI, p. 187.

57. Jean Charlot, *The Mexican Mural Renaissance: 1920–1925* (New Haven: Yale University Press, 1963), p. 65.

58. Dr. Atl, *Los artes populares en México* (Mexico City: Editorial Cultura, 1922), 2 vols. The first edition consists of a single, very thin volume that bears the inauguration date of the exhibition as its publication date (19 September 1921). It would not have been useful as a catalogue or guide to the exhibition, since its coverage was superficial. Apparently it was intended as a souvenir.

59. Manuel Romero de Terreros y Vinent, *Las artes industriales en la Nueva España* (Mexico City: Librería de Pedro Robredo, 1923). See Figs. 8, 37, 77, 83, 84, 88.

60. DBI, pp. 26–27.

61. Ibid., pp. 179–80.

62. Ibid., p. 17.

63. Ibid., p. 137.

64. Ibid., p. 141.

65. Ibid., pp. 64, 32.

66. Ibid., p. 66.

67. Ibid., p. 16.

68. Ibid., pp. 73–74.

69. Charlot, p. 37.

70. Edward Weston to Flora Weston, 22 February 1924, WE.

71. DBI, p. 79.

72. Ibid., pp. 85–86.

73. In 1912, Weston had made a conventional still life, a photograph titled "Almond Blossoms," which showed almond-tree branches in blossom. Traditionally, a still life is a composition based on inanimate objects that can be manipulated; Weston, however, made photographs that included people exclusively for their decorative value and for their contribution as forms. These pictures would never be mistaken for portraits, even if he labeled them as such, as in the arrangement with Ruth Shaw he titled "R. S.—A Portrait" from 1922.

74. DBI, pp. 167, 93.

75. Ibid., p. 150.

76. Ibid., p. 130.

77. Ibid., p. 69.

78. Ibid., pp. 93–94, 101, 105.

79. Ibid., pp. 26, 36, 91.

80. Ibid., pp. 36, 154, 158, 160.

81. Ibid., pp. 30, 34, 156; interview with Mrs. Patrick O'Hea, 8 October 1980. The portrait of Harry Wright is not mentioned in the *Daybooks* but, like those of the Braniffs and others, it is listed in the unsigned review, "Weston's Exhibition This Year Shows Examples of Unusually Beautiful Photography," *Universal* [Mexico City], 27 October 1924. Wright's role in the U.S. community in Mexico City was described in the social pages of *The Mexican-American*, a weekly newspaper published for the U.S. colony in Mexico (28 June 1924; 13 September 1924).

82. DBI, p. 141.

83. *Universal*, 27 October 1924; "Amusements," *Mexican-American*, 18 October 1924, p. 45; F[rancisco] M[onterde] G[arcía] I[cazbalceta], "La exposición de Edward Weston," *Antena* no. 5 (November 1924):10–11, facsimile series Revistas Literarias Mexicanas Modernas (Mexico City: Fondo de Cultura Económica, 1980). The reviews in *Mexican-American* and *Universal*, and Weston himself, specified that the exhibition consisted of over 100 prints, all done in Mexico. In a letter to Hagemeyer, written right before he went off to the opening, (W/H, 15 October 1924), Weston stated that he had just hung a show of 70 prints, all done in Mexico.

84. DBI, p. 96.

85. DBI, p. 98; "El cielo de México," *La Antorcha* 7 (15 November 1924):

20–21. A catalogue to this exhibition was printed. The GEH, the WE, and the CCP do not have copies. It is, however, mentioned in Harold Henry Jones III, "The Works of Photographers Paul Strand and Edward Weston: With an Emphasis on Their Work in New Mexico" (M.F.A. dissertation, University of New Mexico, 1972), p. 176, and Bernard Freemesser, "A Chronological Bibliography," *Exposure* 15 (February 1977): 29.

86. DBI, pp. 97, 99.

87. In 1929, Tina Modotti described the photographic situation she knew in Mexico: "to show . . . *what can be done* [in Mexico], without recurring to colonial churches and charros and chinas poblanas [cowboys and beautiful native girls], and the similar trash most photographers have indulged in" (Modotti to Weston, 17 September 1929, WE).

A year later she compared photographic accomplishments in Germany, which impressed and intimidated her, to the state of the art in Mexico, "the trash turned out in Mexico by the photographers we both knew . . ." (Modotti to Weston, n.d. [probably June or July 1930], WE).

88. García Icazbalceta, *Antena*, pp. 10–11.

Chapter 2

1. DBI, pp. 113, 115.

2. Weston to Stieglitz, 3 March 1925, Beinecke Rare Book and Manuscript Library, Yale University.

3. For example, consider the number of interesting photographs Weston took in Mexico and never mentioned; compare his description and Anita Brenner's of his activities on 17 October 1926 (Chapter 3 below); moreover, except for two printed pages, the *Daybooks* ceased completely soon after his relationship with Charis Wilson became solidified.

4. W/H, 14 July 1925.

5. Edward Weston to Miriam Lerner, 15 October 1925, Bancroft Library, University of California, Berkeley. Quoted by permission.

6. Ibid., 6 April 1926.

7. [Edward Weston] to Willard Van Dyke, 18 April 1938, CCP.

Chapter 3

1. Weston to Stieglitz, n.d. [late 1925], from "Stieglitz–Weston Corre-spondence," compiled by Ferdinand Reyher, *Photo Notes*, Spring 1949, p. 12; republished in *Creative Camera*, October 1975, p. 334.

2. DBI, p. 127.

3. J. M. H., "Mañana se clausurará la magnífica exposición de Weston y Modotti. Weston, el emperador de la fotografía, no obstante de que nació en Norte América, tiene alma latina," *El Sol* [Guadalajara], 5 September 1925.

4. [David] Alfaro Siqueiros, "Una Trascendental labor fotográfica: la ex-posición Weston-Modotti," *El Informador* [Guadalajara], 5 September 1925.

5. Weston to Lerner, 17 September 1925, Bancroft Library, University of California at Berkeley. Quoted by permission.

6. "Los Artistas Weston y Modotti salieron para México," *El Sol* [Guadala-jara], 9 September 1925.

7. Anita Brenner, "Edward Weston nos muestra nuevas modalidades de su talento," *Revista de Revistas*, 4 October 1925, p. 17; Diego Rivera, "Edward Weston and Tina Modotti," *Mexican Folkways* 2 (April–May 1926): 16–17, 27–28; Edward Weston, "Photography," *Mexican Life* 2 (June 1926): 16–17.

8. DBI, p. 132; he seems to have put the phrase "form follows function" in writing at least twice previously: DBI, p. 55 and Weston, "New York Notes," p. 8.

9. DBI, p. 133.

10. Ibid., pp. 136, 138.

11. Ibid., p. 145.

12. W/H, 6 December 1925.

13. DBI, pp. 130, 153.

14. DBI, pp. 151, 154, 200.

15. Diego Rivera, "Mexican Painting: Pulquerías," *Mexican Folkways* 2 (June–July 1926): 6–15.

16. DBI, p. 161.

17. Weston to Van Dyke, 18 April 1938.

18. DBI, p. 99.

19. Ibid., p. 144.

20. Ibid., p. 156.

21. W/B, 5 May 1926.

22. DBI, pp. 158, 159.

23. "Minuta del contrato que celebran la Señorita Anita Brenner y la Universidad," 29 April 1926.

24. W/B, n.d. [14 July 1926?], 23 July 1926, 6 August 1926, 10 August 1926, n.d. [14–15 October 1926], and 3 November 1926.

25. Anita Brenner, "Edward Weston nos muestra nuevas modalidades de su talento," *Revista de Revistas* (4 October 1925), p. 17.

26. DBI, p. 163.

27. His 8-by-10-inch camera was a Seneca View Camera, available since about 1916. It had a folding drop bed, reversible back, double extension bellows, horizontal and vertical swings in the rear, rising front, radial rack-and-pinion focusing, and no shutter; this camera can be identified only because of Tina Modotti's portrait of Weston made in Mexico.

28. Conversation with Brett Weston, 24 November 1980.

29. Anita Brenner, *Idols behind Altars* (New York: Payson and Clarke, 1929), p. 6.

30. Vestal, p. 6.

31. W/B, 28 June 1926; also see DBI, pp. 169–70, 174.

32. DBI, pp. 69, 101.

Without any explanation, Mildred Constantine assigned a version of *Our Lord of the Tree* from the museum in Morelia to Tina Modotti (p. 123). A contact print in the Anita Brenner Collection which was made from the full, roll-film negative indicates that neither Tina nor Edward was the author of it since they were both making larger sheet-film negatives. For both stylistic and technical reasons, the twenty-eight other negatives that originally accompanied this one in the collection cannot be attributed to Weston and Modotti.

A head of an eighteenth-century wooden Christ is, however, definitely by Tina Modotti; the Museum of Modern Art in New York has a signed print dated 1925 (Brenner, *Idols*, fig. 18). The print was, therefore, not made on the expedition and there is no copy of it in the Brenner Collection. In 1927, that piece of sculpture was located in the Proal Collection in Mexico City (interview

with Gabriel Fernández Ledesma [editor of *Forma*], 18 June 1981; *Forma* 1, no. 5
[1927]: 8).

Most other photographs by Tina of popular art objects are evenly and flatly illuminated. She consistently used a plain ground and placed the objects on it fairly symmetrically, without conveying a sense of rhythm or any delight or amusement that might have been provoked by the object itself. Modotti to Weston, 7 July 1925, 23 May 1930, and n.d. [June or July 1930], WE.

33. Tina Modotti, "Pátzcuaro," *Mexico This Month* 1 (July 1955): 18.

34. For example, Brenner reproduced two different Weston photographs of the same painted vase by Amado Galván in *Mexico This Month*. In 4 (February 1958): 21, she credited the photograph to Weston; however, in 8 (July 1962): 15, and in 13 (October–November 1968): 38, she did not—even though the first was annotated by Weston on the back, and the other was published in *Idols behind Altars* (Fig. 30).

"*El Rato*" appeared as figure 47 in *Idols behind Altars*, but when it was published in *Mexico This Month*, no credit was given (15 [August–September 1969]: 36).

Other examples of Weston not receiving credit can be found in 8 (July 1962): 19; 11 (January 1966): 11, 16, 21; 11 (July 1966): 14, 16; 11 (September–October 1966): 21, 26, 40; 15 (May–June 1969): 10–11; 15 (June 1969): 11–13; 15 (August–September 1969): 37, 40, 42.

35. W/B, 23 July 1926.

36. Figure 18, the head of an eighteenth-century wooden Christ, was by Tina Modotti.

37. W/B, 28 October 1929; Modotti to Brenner, 9 October 1929, Anita Brenner Collection.

38. W/B, 30 June 1926.

39. For example, Padre Ricardo, an English priest whom D. H. Lawrence had known in Oaxaca, was arrested and deported the night before Weston went to visit him (DBI, p. 168).

40. W/B, 28 June 1926, 24 August 1926; on 10 August 1926, he wrote Anita: "One enters a church at some risk these days." On another occasion, he observed: "The severity of the ruling might result in civil war" (DBI, p. 174).

41. W/B, 28 June 1926.

42. Ibid., n.d. [ca. 10 June 1926], 14 June 1926.

43. DBI, p. 162.

44. Ibid., p. 165; W/B, 24 June 1926, 28 June 1926.

45. W/B, 28 June 1926.

46. Ibid., and n.d. [ca. 4 July 1926].

47. Ibid., n.d. [14 July 1926?].

48. W/B, n.d. [20–21 July 1926]. Weston wrote: "We were ready to leave Morelia after working in the Museum. The Indians lacked the character, as did their crafts, of those in Oaxaca. The church interiors had been stripped of all interest" (DBI, p. 171).

49. W/B, 23 July 1926; DBI, pp. 171–72.

50. DBI, p. 172.

51. Ibid., p. 173.

52. Ibid., p. 175.

53. Ibid., p. 201.

54. DBI, p. 173; W/B, 23 July 1926.

55. In one of his letters to Anita (n.d. [14–15 October 1926]) Weston referred to a collection of negatives he had made which belonged to Pallares. Then, in a letter written in the late spring of 1929, Tina, considering that she might be deported (which took place in January 1930), asked Weston what he wanted her to do with his negatives (WE). The context, however, suggests that she might have been referring to portrait negatives he left with her.

56. W/B, 24 August 1926.

57. DBI, pp. 188–91; despite the impression given by Weston's wording here, photographs by Sheeler were not included in the reprint of the Spring issue of *Little Review*, even though works by the other photographers he mentioned are.

58. DBI, pp. 191–93; Anita Brenner's journal, 15 September–14 October 1926, no pag.

59. DBI, p. 196.

60. DBI, pp. 192, 194.

61. Ibid., p. 196.

62. Ibid., pp. 197–98.

63. Ibid., p. 199; W/B, 3 November 1926.

64. DBI, p. 197.

65. DBII, p. 98.

66. DBI, p. 168; Weston to Brenner, 14 June 1926.

67. DBI, p. 163.

68. Weston mentioned to Van Dyke that he had made more than 1,300 negatives during the first year of his Guggenheim Fellowship (Weston to Van Dyke, 18 April 1938, WE).

69. DBII, p. 155. [Edward Weston], "*Statement—," [1929], copy in Beaumont Newhall Library, Santa Fe, NM.

70. DBII, pp. 79, 210.

71. DBI, p. 165.

72. Ibid., p. 190.

Chapter 4

1. DBII, p. 3.

2. Ibid., p. 4.

3. Ibid., p. 247.

4. Or, as Weston wrote: "when exhibiting I usually select everything from one period—that which interests me most: the present" (Weston to Van Dyke, 18 April 1938).

When Nancy Newhall was collecting photographs for his 1946 show at the Museum of Modern Art in New York, he informed her that 2 percent of the show had been "made last month! Not printed but *photographed*" (W/N, n.d. [July 1945?].

This predilection for the present is dramatically illustrated by the way he selected works for his own exhibits, publications, and portfolios; in general, the more distant the period, the fewer works from it he included:

	Total No. of Photographs	1903–23 (Calif.)	1923–26 (Mexico)	1927 and later
Los Angeles County Museum Exhibition (1927):	102	5%	68%	19%
Merle Armitage: *The Art of Edward Weston* (1932):	39	2.5%	10%	87.5%
Morgan Camera Shop Show, Los Angeles (1939):	198	7%	25%	68%

(*continued next page*)

	Total No. of Photographs	1903–23 (Calif.)	1923–26 (Mexico)	1927 and later
Museum of Modern Art Exhibition, NY (1946):	ca. 317	7%	11%	82%
Project Prints (ca. 1952–1954):	832	2%	7%	91%

5. "Fotografías de Weston," *Forma* 2 (1928): 15–18.

6. García Icazbalceta, *Antena*, pp. 10–11.

7. Interview with Gabriel Fernández Ledesma, 18 June 1980. Tina once offered to show Fernández Ledesma Weston's prints of shells to see if he "wanted" some, but no mention of other contact has been located (Tina Modotti to Edward Weston, 25 June 1927, WE).

8. "CONCEPTOS DEL ARTISTA

He registrado la quintaesencia del objeto o elemento frente a mi lente, sin subterfugios ni evasivas, así en la técnica como en el espíritu, en lugar de ofrecer una interpretación, un aspecto superficial o pasajero.

La fotografía no vale nada cuando imita a otro medio de expresión, valiéndose de trucos técnicos o de puntos de vista ajenos.

Emocionalismo incoherente debe ser sustituido por pensamiento sereno; la habilidad mañosa debe ceder su lugar a la honradez.

La fotografía se ha debilitado por un abuso de impresionismo anemico. Impresionismo quiere decir escepticismo que da más importancia a lo que se nota casualmente que a aquello que se sabe positivamente.

La fotografía tomará su lugar entre las artes creadoras, sólo cuando este acompañada de una sinceridad de propósito y de una comprensión sólida de las más sutiles posibilidades de este medio de expresión" (Edward Weston, "Conceptos del artista," *Forma* 2 [1928]: 17).

9. [Weston], "*Statement—," [1929].

10. Edward Weston, untitled statement for Film und Foto Ausstellung, Stuttgart: 1929, WE.

11. DBII, p. 207.

12. Ibid., p. 250.

13. Ibid., p. 207.

14. Charlot to Weston, envelope dated 15 August 1927, WE.

15. DBI, p. 192.

Selected List of References

The most complete bibliographies on Edward Weston are:

Freemesser, Bernard. "Edward Weston: A Chronological Bibliography." *Exposure* 15 (February 1977): 29–32.

Fuller, Pat. "Bibliography." In *Ben Maddow, Edward Weston: Fifty Years*, pp. 279–85. Millerton, N.Y.: Aperture, 1973.

Johnson, William. "Dear Editor [Works on or by Weston omitted from the Freemesser bibliography]." *Exposure* 15 (May 1977): 53–65.

Works Written by Edward Weston

"Conceptos del Artista." *Forma* 2 (1928): 17–18.

"Los daguerrotipos." *Forma* 1 (October 1926): 7.

The Daybooks, Volume I. Mexico and *Volume II. California*. Edited and introduced by Nancy Newhall. Rochester, N.Y.: George Eastman House, 1961 and Rochester, N.Y.: George Eastman House and N.Y.: Horizon Press, 1966; Millerton, N.Y.: Aperture, 1973.

The Flame of Recognition. 3d ed. Edited by Nancy Newhall. N.Y.: Grossman Publishers [An Aperture Book]. 1971.

"Photography." *Mexican Life* 2 (June 1926): 16–17.

"*Statement—." [1929]. WE.

"Stieglitz-Weston Correspondence." Compiled by Ferdinand Reyher. *Photo Notes*, Spring 1949, pp. 11–15; reprinted in *Creative Camera*, October 1975, pp. 334–35.

"Weston to Hagemeyer: New York Notes." *Center for Creative Photography* no. 3 (November 1976): 1–12.

Untitled Statement for Film und Foto Ausstellung, Stuttgart. [1929]. WE.

Works Written About Edward Weston or Illustrated by Him:

"Amusements." *Mexican-American*, 18 October 1924, p. 45.

Brenner, Anita. "Edward Weston nos muestra nuevas modalidades de su talento." *Revista de Revistas*, 4 October 1925, p. 17.

——. *Idols behind Altars*. New York: Payson and Clarke, 1929.

"El cielo de México." *La Antorcha* 7 (15 November 1924): 20–21.

Córdova, Rafael Vera de. "Las fotografías como verdadero arte." *El Universal Ilustrado*, 23 March 1922, pp. 30–31, 55.

Davis, Keith F. *Edward Weston. One Hundred Photographs*. [Kansas City:] University Trustees of the William Rockhill Nelson Trust and Hallmark Cards, 1982.

Foley, Kathy Kelsey. *Edward Weston's Gifts to His Sister*. Dayton: Dayton Art Institute, 1978. [Includes essays by Ben Maddow and Charis Wilson.]

"La fotografía de Edward Weston." *Nuestra Civdad* 2 (October 1930). Unpaginated.

García Icazbalceta, Francisco Monterde [F. M. G. I.]. "La exposición de Edward Weston." *Antena* no. 5 (November 1924): 10–11; reprint ed., *Revistas literarias mexicanas modernas*, Mexico City: Fondo de Cultura Económica, 1980; also printed as "Fotografías de Weston," in *Forma* 2 (1928): 15–16.

Maddow, Ben. *Edward Weston: Fifty Years*. Millerton, N.Y.: Aperture, 1973.

——. *Edward Weston: Seventy Photographs*. First paperback edition. Boston: N.Y. Graphic Society [An Aperture Book], 1978.

Newhall, Beaumont. "Edward Weston in Retrospect." *Popular Photography* 18 (March 1946): 42–46, 142–44, 146.

——. "Edward Weston's Technique." In *The Daybooks of Edward Weston. Volume I. Mexico*.

Newhall, Nancy. "Edward Weston and the Nude." *Modern Photography* 16 (June 1952): 38–43, 107–10.

————. "Introduction." In *The Daybooks of Edward Weston. Volume I. Mexico.*

Rivera, Diego. "Edward Weston and Tina Modotti." *Mexican Folkways* 2 (April–May 1926): 16–17, 27–28.

————. "Mexican Painting: Pulquerías." *Mexican Folkways* 2 (June–July 1926): 6–15.

Siqueiros, David Alfaro. "Una trascendental labor fotográfica: la exposición Weston—Modotti." *El Informador* [Guadalajara], 5 September 1925.

"Weston's Exhibition This Year Shows Examples of Unusually Beautiful Photography." *Universal*, 27 October 1924, p. 2.

Background Material

Baciu, Stefan. *Surrealismo latinoamericano: preguntas y respuestas.* Valparaiso, Chile: Ediciones Universitarias, 1979.

Beals, Carleton. *Mexico: an Interpretation.* New York: E. W. Huebsch, 1923.

————. *Mexican Maze.* Philadelphia: J. B. Lippincott Co., 1931.

Charlot, Jean. *The Mexican Mural Renaissance: 1920–1925.* New Haven: Yale University Press, 1963.

Fernández Ledesma, Gabriel. *Juguetes mexicanos.* Mexico City: Talleres Gráficos de la Nación, 1930.

————. "El sentimiento estético de los juguetes mexicanos." *Forma* 1 (October 1926): 32–33; 1 (n.d.): 38–39; 1 (n.d. [1927]): 34–35; 1 (1927): 18–19; 1 (1928): 30–31.

Gottlieb, Robert and Irene Wolt. *Thinking Big: the Story of the Los Angeles Times, Its Publishers, and Their Influence on Southern California.* New York: G. P. Putnam's Sons, 1977.

Gruening, Ernest. *Many Battles.* New York: Liveright, 1973.

————. *Mexico and Its Heritage.* New York: Century Co., 1929.

List Arzubide, German. *Movimiento estridentista.* Jalapa, Veracruz: Ediciones de Horizonte, 1926; reprint ed., Mexico City: Federación Editorial Mexicana, 1980.

Murillo, Gerardo [Dr. Atl]. *Los artes populares en México*. Mexico City: Editorial Cultura, 1922.

Porter, Katherine Anne. *Outline of Mexican Arts and Crafts*. Los Angeles: Young and McCallister, 10 November 1922.

Priestley, Herbert J. *The Mexican Nation, a History*. New York: Macmillan Co., 1923.

Romero de Terreros y Vinent. *Las artes industriales en la Nueva España*. Mexico City: Librería de Pedro Robredo, 1923.

Schneider, Luis Mario. *Estridentismo: una literatura de la estrategía*. Mexico City: Instituto Nacional de Bellas Artes, 1970.

Wolfe, Bertram. *The Fabulous Life of Diego Rivera*. New York: Stein and Day, 1963.

Archival Material

Anita Brenner Collection. Anita Brenner's journal, correspondence, and miscellaneous papers.

Berkeley, Calif. University of California, Berkeley. Bancroft Library. Miriam Lerner–Edward Weston correspondence.

New Haven, Conn. Yale University. Beinecke Rare Book and Manuscript Library, Collection of American Literature. Alfred Stieglitz–Edward Weston correspondence.

New York, N. Y. Museum of Modern Art. Department of Photography. Beaumont and Nancy Newhall–Edward Weston correspondence and miscellaneous papers.

Private Collections. Miscellaneous papers and correspondence.

Santa Fe, N.M. Beaumont Newhall Library. Correspondence, manuscripts, and notes written by Beaumont and Nancy Newhall.

Tucson, Ariz. University of Arizona at Tucson. Center for Creative Photography. Miscellaneous material; Johan Hagemeyer–Edward Weston correspondence and papers; Edward Weston's "Log"; correspondence to Edward Weston from Jean Charlot, Imogen Cunningham, Tina Modotti, William Porterfield, May Weston Seaman, Roubaix de l'Abrie Richey, Edward Brett Weston, and others.

Interviews and Conversations

Monna Alfau

Manuel Alvarez Bravo

Beatriz Braniff Cornejo

Marco Díaz

Gabriel Fernández Ledesma

Gunther Gerso

Rose Krasnow

German List Arzubide

Ben Maddow

Yolanda Modotti Magrini

Manuel Maples Arce

Guadalupe Marín

Carlos Orozco Romero

Otto Schondube

Jean Seaman

Dody Thompson

Raquel Tibol

Brett Weston

Chandler Weston

Cole Weston

Neil Weston

Charis Wilson

Ella Wolfe

Mr. and Mrs. Harry Wright

Jake Zeitlin

J. Vincente Zuno Arce

Introduction to the Checklist of Photographs in the Exhibition

All of Weston's photographs in Mexico were taken with two cameras, which were outfitted with several lenses. He had a 3¼-by-4¼-inch Graflex, a hand-held camera, which he used for snapshots, for many of his portraits, and occasionally for other compositions when the bulk created by his 8-by-10-inch Seneca view camera, which had to be set on a tripod (or in the case of the "*Excusado*," rested on the floor) would have been uncomfortable, unfeasible, or embarrassingly conspicuous—or when its bellows were leaking light,· which occurred fairly frequently.

Weston did not enlarge his prints. When he wanted or needed a larger print from a 3¼-by-4¼-inch negative, he shot an enlarged positive on film or glass, made a contact negative from that, and finally, a contact print. He believed that this method gave him the greatest control over definition and tonality, which were of primary importance to his way of seeing and to what he valued.

Six categories of prints by Edward Weston are included in this exhibition, all of which were made from original negatives, and all of which, unfortunately, look alike in reproductions. In a few instances two interpretations of the same image are exhibited, one perhaps a vintage exhibition print, the other a project print. This lets the spectator appreciate certain changes in Weston's preferences from the mid 1920s to the mid 1950s. In almost all the prints being exhibited, it is the photograph with which Weston was concerned, not just the image.

The six categories of prints being shown are:

99

Vintage Exhibition Prints. These were normally made by Weston within a decade of when he made the negative. He considered them to be of exhibition quality, and they were usually signed. They are mat-surfaced, whether the paper he was using was gelatin silver, palladium, or platinum. This distinction, however, is irrelevant since Weston was capable of making a silver print that appears to be a platinum print and can sometimes deceive the most knowledgeable connoisseur today.

Press Prints (so called for lack of a better word). Rarely signed, these photographs were made with the idea that they might be used as reproductions in a publication. Therefore, the contrast is slightly higher than that in a vintage exhibition print, and a very thin, smooth, and glossy—although not ferro-typed—gelatin silver photographic paper was used. All of Weston's pictures for the University of Mexico/Anita Brenner project fall within this category, as do many others. Their existence should encourage critics and historians to reconsider all the discussion about how, when, and why Weston began to make glossy photographs: Did Brett Weston introduce him to the idea in Mexico in 1925–1926? Was it a consequence of the 1929 Film und Foto Exhibition in Stuttgart? How did this change relate to the f. 64 movement in 1932? Clearly, however, the need for this type of picture in the mid 1920s did influence Weston's later decision to make glossy exhibition photographs. Ironically, it is this category of print which Weston's admirers today are most accustomed to seeing and associating with him since his works are usually reproduced on glossy stock in black and white, not on fibrous paper in delicate tones of sepia.

Edition Prints. In 1930, Weston began numbering his prints (e.g., "4/50") and keeping records of how many of each he had made. The largest edition of any photograph he made in Mexico was that of the 25 prints he listed of "Maguey, Texcoco." These edition prints are on mat-surfaced, gelatin silver paper and are often mistaken for platinum prints.

Project Prints. Between about 1952 and 1954, about 832 negatives made by Weston from 1920 through 1948 were reprinted under his supervision by his sons Brett and Cole with the help of Dody Thompson. Between five and ten gelatin silver prints from each were made and shown to him for his approval. A complete set of them exists in Special Collections at the University of California Library in Santa Cruz.

Snapshots. Taken with his Graflex camera, these pictures were made as visual "recuerdos," souvenirs. He intended them for the enjoyment of those involved and probably never considered that they might someday be exhibited.

Modern Prints. After Edward's death in 1958, both Brett and Cole made additional prints from their father's negatives. These are always labelled as such.

Checklist of Photographs
in the Exhibition

If the title of a photograph by Edward Weston is both in italics and between quotation marks, he assigned that title or referred to it or to the subject in that way, or it was given that title at the time it was made. If, however, it is only in italics, the title has been recently assigned to facilitate identification. The year noted indicates the latest date he could have made the negative, not the year the print was made.

*Height is always indicated before width; * indicates that the photograph is illustrated in this catalogue; + means that the photograph will not travel to all the museums receiving the exhibition.*

* Tina Modotti (?) [frontispiece]
 Edward Weston with his 8 by 10 inch Seneca View Camera with a Graf Variable Lens, Mexico, ca. 1924
 Vintage exhibition print, gelatin silver, 8.2 by 10.2
 Courtesy of the Amon Carter Museum, Fort Worth, Texas

 "Ricardo Gómez Robelo," 1921
 Vintage exhibition print, platinum or palladium, 19.0 by 24.0
 Collection of the Art Institute of Chicago, Illinois

Xavier Guerrero (proof), 1922
Proof for a vintage exhibition print, gelatin silver, 25.0 by 20.3
Jean Charlot Collection, Thomas Hale Hamilton Library, University of
 Hawaii at Manoa, Honolulu, Hawaii

Xavier Guerrero, 1922
Vintage exhibition print, gelatin silver, 23.6 by 18.1
Collection Ex Libris, New York

* Pablo Picasso [Figure 2]
The Watering Place, 1905
Fine Arts Museums of San Francisco: Achenbach Foundation for the Graphic
 Arts

* *"The Great White Cloud of Mazatlán,"* 1923 [Plate 1]
Vintage exhibition print, platinum or palladium, 22.8 by 17.8
Collection of the Oakland Museum, Oakland, California: Gift of Dr. and Mrs.
 Dudley P. Bell

"Hotel—First Day in Mexico City," 1923
Snapshot, gelatin silver, 7.5 by 10.1
Collection of the Center for Creative Photography, Tucson, Arizona

"Bomba en Tacubaya," 1923
Project print, gelatin silver, 24.5 by 19.7
University Library, Special Collections, University of California, Santa Cruz

Tina Modotti Seated in a Doorway at Tacubaya, 1923
Vintage exhibition print, platinum or palladium, 12.0 by 9.8
Collection of Mildred Constantine, New York

* *Elisa Guerrero*, 1923 [Figure 3]
Vintage exhibition print, gelatin silver, 24.1 by 17.5
Courtesy G. Ray Hawkins Gallery, Los Angeles

* *"Nahui Olín,"* 1923 [Figure 17]
Vintage exhibition print, platinum or palladium, 23.0 by 18.0
San Francisco Museum of Modern Art, Extended Anonymous Loan

"*Nahui Olín,*" 1923
Vintage exhibition print, gelatin silver, 22.8 by 17.5
Collection of Harvey Himmelfarb and Alice Swan, Davis, California

+ *"Guadalupe Marín" de Rivera*, 1923
Project print (?), gelatin silver, 20.8 by 17.8
Collection of the International Museum of Photography at George Eastman
 House, Rochester, New York

* *"Pirámide del Sol," Teotihuacán*, 1923 [Figure 18]
Edition print, gelatin silver, 18.5 by 24.2
San Francisco Museum of Modern Art, Promised Gift from Brett Weston

"La Ciudadela," Teotihuacán, 1923
Vintage exhibition print, platinum or palladium, 17.8 by 24.1
Collection of the Museum of Modern Art, New York

Tina Modotti Nude on the Azotea, 1923
Project print, gelatin silver, 18.5 by 24.0
University Library, Special Collections, University of California, Santa Cruz

Tina Modotti, Nude on the Azotea, with a Pyramid of Light, 1924
Project print, gelatin silver, 18.7 by 23.6
University Library, Special Collections, University of California, Santa Cruz

Tina Modotti, "Hands Against Kimono," 1924
Project print (?), gelatin silver, 24.0 by 19.0
Courtesy of the Weston Gallery, Carmel, California

+ *Tina Modotti, Breast and Kimono*, 1924
Vintage exhibition print, gelatin silver, 7.3 by 9.8
Collection of the International Museum of Photography at George Eastman
 House, Rochester, New York

* *Tina Modotti, Half Nude in Kimono*, 1924 [Figure 20]
Vintage exhibition print, gelatin silver, 24.5 by 12.2
San Francisco Museum of Modern Art, Purchase (62.1184)

"Tina Modotti Reciting Poetry," I, 1924
Vintage exhibition print, platinum or palladium, 24.5 by 19.0
Museum of Fine Arts, Houston: Museum Purchase with Funds Provided by
 Target Stores, Inc.

* *"Tina Modotti Reciting Poetry," II*, 1924 [Figure 1]
Vintage exhibition print, gelatin silver, 23.6 by 18.8
Courtesy of the Weston Gallery, Carmel, California

"Tina Modotti Reciting Poetry," III, 1924
Press print, gelatin silver, 24.0 by 17.0
Collection of Zohmah Charlot, Honolulu, Hawaii

"Tina Modotti" with a Tear on Her Cheek, 1924
Vintage exhibition print, gelatin silver, 22.5 by 17.0
Collection of the Museum of Modern Art, New York

+ *Manuel Hernández "Galván—Shooting,"* 1924
Vintage exhibition print, platinum or palladium, 22.5 by 18.5
Museum of Fine Arts, Boston: Mary L. Smith Fund, 1970.480

* *Manuel Hernández "Galván—Shooting,"* 1924 [Figure 15]
Project print, gelatin silver, 21.9 by 18.7
San Francisco Museum of Modern Art, Purchase (62.1183)

+ Unknown Photographer (?)
"El Desierto de los Leones—Tina—Galván—Chandler—Pepe and E," 1924
Snapshot, platinum or palladium (?), 7.4 by 10.0
Collection of the International Museum of Photography at George Eastman
 House, Rochester, New York

Manuel Hernández Galván, Monna Alfau, Tina Modotti, and Others, ca. 1925
Snapshot, gelatin silver, 7.6 by 10.2
Private Collection

* Unknown Photographer [Figure 16]
Felipe Teixidor, Tina Modotti, Pepe, Manuel Hernández Galván, Edward Weston, Monna
 Alfau, and Rafael Sala in the Countryside, 1924
Snapshot, gelatin silver, 7.5 by 10.3
Private Collection

* *Monna Alfau Laughing*, 1924 [Figure 4]
Snapshot, gelatin silver, 10.0 by 7.5
Private Collection

Monna Alfau, Profile, 1924
Vintage exhibition print, 9.5 by 7.0
Private Collection

+ *Portrait of Monna Alfau with Shadows*, 1924
Vintage exhibition print, platinum or palladium, 7.3 by 9.5
Museum of Fine Arts, Boston: Sophie M. Friedman Fund, 1979.16

* *"Rafael Sala," Seated*, 1924 [Figure 5]
Vintage exhibition print, gelatin silver, 17.5 by 22.5
Collection of the Museum of Modern Art, New York

* *"Rafael Sala," Seated*, 1924
Vintage exhibition print, gelatin silver, 17.5 by 22.5
Private Collection

"Rafael Sala" Standing with a Portfolio, 1924
Vintage exhibition print, gelatin silver, 23.7 by 19.0
Collection of the Museum of Modern Art, New York

"Rafael Sala" Standing with One of His Paintings Hanging on the Wall, 1924
Vintage exhibition print, gelatin silver, 23.5 by 19.5
Collection of the Museum of Modern Art, New York

* *"Diego Rivera" Smiling*, 1924 [Figure 9]
Vintage exhibition print, gelatin silver, 18.5 by 18.0
San Francisco Museum of Modern Art, Evelyn and Walter Haas, Jr., Fund
 Purchase (83.20)

+ *"Diego Rivera," Frontal*, 1924
Vintage exhibition print, gelatin silver, 9.2 by 7.1
Collection of the International Museum of Photography at George Eastman
 House, Rochester, New York

"Diego Rivera" in Front of a Painted Pot, 1924
Press print (?), gelatin silver, 18.9 by 23.6
Jean Charlot Collection, Thomas Hale Hamilton Library, University of
 Hawaii at Manoa, Honolulu, Hawaii

"Diego Rivera," His Hand on His Hip, Looking Down, 1924
Snapshot, gelatin silver, 9.5 by 7.4
Jean Charlot Collection, Thomas Hale Hamilton Library, University of
 Hawaii at Manoa, Honolulu, Hawaii

Beatriz Cornejo de Braniff, 1924
Vintage exhibition print, platinum or palladium, 24.3 by 19.0
Collection of Beatriz Braniff, Mexico City

Two "Swan Gourds," 1924
Press print, gelatin silver, 18.5 by 20.5
Courtesy of the Weston Gallery, Carmel, California

* *"Caballito de Cuarenta Centavos"* or *"Horsie,"* 1924 [Figure 7]
Press print, gelatin silver, 19.2 by 23.3
Collection of the California Museum of Photography, University of Califor-
 nia, Riverside: Extended Loan from Hardie C. Setzer

Stairwell of the Colegio of "San Pedro y San Pablo," 1924
Project print, gelatin silver, 19.2 by 23.4
University Library, Special Collections, University of California, Santa Cruz

* *"Circus Tent,"* 1924 [Plate 3]
Vintage exhibition print, gelatin silver, 23.7 by 18.0
Collection of the Oakland Museum, Oakland, California; lent by Mr. and
 Mrs. Edward Weston

* *"El Cielo de México,"* 1923–1924 [Figure 19]
 La Antorcha, 15 November 1924, pp. 20–21
 Private Collection

 "Plaza Tepotzotlán," I, 1924
 Vintage exhibition print, platinum or palladium, 19.2 by 24.3
 Collection of the Museum of Modern Art, New York

+ *"Plaza Tepotzotlán," II*, 1924
 Snapshot, gelatin silver, 9.9 by 7.4
 Collection of the International Museum of Photography at George Eastman
 House, Rochester, New York

 "Plaza Tepotzotlán," III, 1924
 Snapshot, gelatin silver, 7.5 by 10.0
 Private Collection

* *"Calle Mayor"* or *"Pissing Indian," Tepotzotlán*, 1924 [Plate 4]
 Project print, gelatin silver, 19.0 by 24.0
 University Library, Special Collections, University of California, Santa Cruz

 "San Cristóbal Ecatepec," 1924
 Vintage exhibition print, gelatin silver, 10.1 by 22.9
 Collection of the Center for Creative Photography, Tucson, Arizona

 Toy Bull, Chandler Weston and Others at San Cristóbal Ecatepec, 1924
 Snapshot, gelatin silver, 7.5 by 10.3
 Private Collection

 "Pyramid" of Teopanzolco "near Cuernavaca," 1924
 Vintage exhibition print, platinum or palladium, 18.7 by 23.2
 Collection of the Museum of Modern Art, New York

 "Desde la Azotea," with Trees, 1924
 Project print, gelatin silver, 19.2 by 24.0
 University Library, Special Collections, University of California, Santa Cruz

"Palma Cuernavaca" with Leaves, 1924
Vintage exhibition print, gelatin silver, 24.0 by 18.9
University Research Library, Special Collections, University of California,
 Los Angeles

"Guadalajara . . . Barranca de los Oblatos: Rocky Trail," 1925
Vintage exhibition print, platinum or palladium, 24.3 by 19.2
Collection of the Museum of Modern Art, New York

* *"Tronco de Palma,"* 1925 [Figure 21]
Vintage exhibition print, platinum or palladium, 24.5 by 17.8
Collection of Zohmah Charlot, Honolulu, Hawaii

* *"Excusado" from Above*, 1925 [Figure 24]
Press print, gelatin silver, 24.5 by 18.9
Instituto Nacional de Bellas Artes: Museo de Arte Moderno, Mexico City:
 Gift from Manuel Alvarez Bravo

+ *"Excusado" from Below*, I, 1925
Project print (?), gelatin silver, 24.0 by 19.1
Collection of the International Museum of Photography at George Eastman
 House, Rochester, New York

+ *"Washbowl,"* 1925
Vintage exhibition print, platinum or palladium, 24.2 by 18.8
Jedermann Collection, U.S.A.

"Washbowl," 1925
Press print, gelatin silver, 24.0 by 18.3
Instituto Nacional de Bellas Artes: Museo de Arte Moderno, Mexico City:
 Gift from Manuel Alvarez Bravo

"Anita," Nude Back, I, 1925
Vintage exhibition print, platinum or palladium, 21.5 by 19.0
Collection of the Museum of Modern Art, New York

* *"Anita," Nude Back, II*, 1925 [Plate 5]
Edition print, gelatin silver, 22.0 by 19.0
Collection of the Krannert Art Museum, University of Illinois, Champaign,
 Illinois

"Anita," Nude Back, III, 1925
Edition print, gelatin silver (?), 21.5 by 19.0
Collection of the Museum of Modern Art, New York

\+ *"Anita," Nude Back, IV*, 1925
Vintage exhibition print, platinum or palladium, 23.9 by 18.8
Collection of the International Museum of Photography at George Eastman
 House, Rochester, New York

Gunther Gerso with His Mother and Sister, 1925
Vintage exhibition print, gelatin silver, 17.9 by 22.0
Collection of Gunther Gerso, Mexico City

"Eric Fisher," I, II, and III, 1925
Vintage exhibition prints, gelatin silver, each 9.6 by 7.2
Collection of Pedro Meyer, Mexico City

Felipe Teixidor, Monna Alfau, Rafael Sala, and Tina Modotti at San Augustín Acolmán,
 1925
Snapshot, gelatin silver, 8.2 by 10.7
Private Collection

* *"Juguetes Mexicanos:" "Ragdoll and Sombrerito,"* 1925 [Plate 2]
Project print, gelatin silver, 24.2 by 18.8
University Library, Special Collections, University of California, Santa Cruz

"Doll in Chair," 1925
Press print, gelatin silver, 23.5 by 17.7
Courtesy of the Weston Gallery, Carmel, California

* *"Mexican Toys": Bull, Pig, Horse, and Plate*, 1925 [Figure 13]
Vintage exhibition print, gelatin silver, 18.7 by 22.0
San Francisco Museum of Modern Art, Byron Meyer Fund Purchase (81.106)

"Bride and Groom" Alone, 1925
Press print, gelatin silver, 24.0 by 18.3
Jean Charlot Collection, Thomas Hale Hamilton Library, University of
 Hawaii at Manoa, Honolulu, Hawaii

"Bride and Groom" Facing Stucco Scrolls, 1925
Project print, gelatin silver, 22.5 by 18.8
University Library, Special Collections, University of California, Santa Cruz

"Cosas de la Vida": Bride and Groom with Pig, 1925
Project print, gelatin silver, 18.5 by 23.5
University Library, Special Collections, University of California, Santa Cruz

"El Vicio y la Virtud": Bride and Fallen Groom, 1925
Project print, gelatin silver, 24.5 by 19.0
University Library, Special Collections, University of California, Santa Cruz

* *"White Heron,"* 1926 [Figure 22]
Press print, gelatin silver, 24.2 by 15.6
Collection of the California Museum of Photography, University of Califor-
 nia, Riverside: Extended Loan from Hardie C. Setzer

* *"Pájaro Blanco,"* 1926 [Figure 23]
Edition print, gelatin silver, 23.8 by 13.8
Collection of the Oakland Museum, Oakland, California: Gift of the Oakland
 Museum Association

"Bird, Penguin, Palma," 1926
Project print, gelatin silver, 19.0 by 24.4
University Library, Special Collections, University of California, Santa Cruz

"Fish Gourd," Bird, and Plate, 1926
Press print, gelatin silver, 19.0 by 24.0
Courtesy of the Weston Gallery, Carmel, California

Fish Gourd, Bowl, and Serape, 1926
Edition print, gelatin silver, 19.0 by 23.7
Courtesy of the Weston Gallery, Carmel, California

+*"*Three Fish—Gourds,*" 1926 [Figure 14]

 Project print (?), gelatin silver, 19.1 by 24.1
 Collection of the International Museum of Photography at George Eastman
 House, Rochester, New York

* *Petate Woman in Front of an Aztec Chair*, 1926 [Figure 12]
 Press print (?), gelatin silver, 23.9 by 19.0
 Courtesy Daniel Wolf, Inc., New York

 Woven Basket and Plate with Four Little Horses, 1926
 Press print, gelatin silver, 20.5 by 18.9
 Courtesy of the Weston Gallery, Carmel, California

* *"Tres Ollas de Oaxaca,"* 1926 [Figure 25]
 Press print, gelatin silver, 19.0 by 21.5
 Courtesy of the Weston Gallery, Carmel, California

* *"Clay Bells" from Oaxaca*, 1926 [Figure 28]
 Press print, gelatin silver, 18.5 by 24.0
 Courtesy of the Weston Gallery, Carmel, California

* *"Charrito" (Pulquería)*, 1926 [Figure 26]
 Edition print, gelatin silver, 19.4 by 24.1
 San Francisco Museum of Modern Art, Extended Anonymous Loan

* *Two Children in Front of a Landscape (Pulquería)*, 1926 [Figure 27]
 Project print, gelatin silver, 24.0 by 18.0
 San Francisco Museum of Modern Art, Extended Anonymous Loan

 "Calle de Rayon" with Moon and Maiden (Pulquería), 1926
 Press print, gelatin silver, 25.2 by 20.3
 Collection of the California Museum of Photography, University of Califor-
 nia, Riverside: Extended Loan from Hardie C. Setzer

 "La Palanca" (Pulquería), 1926
 Press print, gelatin silver, 20.3 by 17.9
 Collection of the California Museum of Photography, University of Califor-
 nia, Riverside: Extended Loan from Hardie C. Setzer

* Matador and Arena (Pulquería),* 1926 [Figure 11]
Press print, gelatin silver, 16.0 by 19.7
Jean Charlot Collection, Thomas Hale Hamilton Library, University of
 Hawaii at Manoa, Honolulu, Hawaii

Cupid and "12 Centavos al Litro" (Pulquería), 1926
Press print, gelatin silver, 22.3 by 16.5
Jean Charlot Collection, Thomas Hale Hamilton Library, University of
 Hawaii at Manoa, Honolulu, Hawaii

"Los Changos Vaciladores" (Pulquería), 1926
Press print, gelatin silver, 18.8 by 24.0
Collection of the California Museum of Photography, University of Califor-
 nia, Riverside: Extended Loan from Hardie C. Setzer

"Girl with Pitcher" in a Landscape (Pulquería), 1926
Press print, gelatin silver, 23.6 by 16.8
Collection of the Center for Creative Photography, Tucson, Arizona

Woman Standing in Front of a Maguey Plant (Pulquería), 1926
Press print, gelatin silver, 22.7 by 19.0
Collection of Zohmah Charlot, Honolulu, Hawaii

Pulquería Interior, 1926
Press print, gelatin silver, 19.0 by 23.7
Collection of the Center for Creative Photography, Tucson, Arizona

* Unknown Photographer [Figure 10]
*Edward Weston Seated in Front of the Pulquería "La Gloria en Triunfo" with Rafael
 Sala, Tina Modotti, and Felipe Teixidor Standing Behind Him,* 1926 (?)
Snapshot, gelatin silver, 10.2 by 7.5
Private Collection

Unknown Photographer
Edward Weston, Brett Weston, and Tina Modotti in a Carriage, 1926 (?)
Snapshot, gelatin silver, 8.1 by 5.4
Private Collection

Rafael Sala, Monna Alfau, Brett Weston, Carleton Beals (?), Tina Modotti, and Edward
 Weston at Tenayuca, I, II, and III, 1926 (?)
Snapshots, gelatin silver, each 8.1 by 5.4
Private Collection

* *"Arcos, Oaxaca,"* 1926 [Figure 29]
 Vintage exhibition print, platinum or palladium, 24.2 by 18.9
 Collection of the Center for Creative Photography, Tucson, Arizona

* *"Heaped Black Ollas" in the Oaxaca Market*, 1926 [Figure 30]
 Vintage exhibition print, gelatin silver, 19.2 by 24.2
 San Francisco Museum of Modern Art, Albert M. Bender Collection, Bequest
 of Albert M. Bender (41.2994)

"Great-Bellied Cat—or Bat" with Pots, 1926
Press print, gelatin silver, 18.8 by 23.5
Collection of the California Museum of Photography, University of Califor-
 nia, Riverside: Extended Loan from Hardie C. Setzer

"Bloody Christ with Weird, Angular Arms," 1926
Press print, gelatin silver, 24.0 by 17.0
Collection of the California Museum of Photography, University of Califor-
 nia, Riverside: Extended Loan from Hardie C. Setzer

Mitla, I, 1926
Press print, gelatin silver, 18.2 by 24.2
Collection of the Center for Creative Photography, Tucson, Arizona

Mitla, II, 1926
Press print, gelatin silver, 18.7 by 23.5
Collection of the Center for Creative Photography, Tucson, Arizona

Mitla, III, 1926
Press print, gelatin silver, 19.1 by 24.1
Collection of the Center for Creative Photography, Tucson, Arizona

Mitla, Three Columns and Courtyard, 1926
Press print, gelatin silver, 18.9 by 23.8
Collection of the Center for Creative Photography, Tucson, Arizona

Mitla: Six Columns and Courtyard, 1926
Press print, gelatin silver, 18.9 by 23.1
Collection of the Center for Creative Photography, Tucson, Arizona

* *"Wheat Heart,"* 1926 [Figure 33]
Press print, gelatin silver, 24.1 by 17.9
Collection of the California Museum of Photography, University of California, Riverside: Extended Loan from Hardie C. Setzer

* *"Tree and Petate," Pátzcuaro*, 1926 [Plate 6]
Press print, gelatin silver, 22.8 by 16.4
Collection of the California Museum of Photography, University of California, Riverside: Extended Loan from Hardie C. Setzer

* *"Janitzio, Lake Pátzcuaro,"* 1926 [Figure 32]
Project print, gelatin silver, 19.0 by 24.0
Collection of the Art Institute of Chicago, Illinois

Don Vasco de Quiroga Fountain, Pátzcuaro, 1926
Press print, gelatin silver, 18.5 by 23.3
Collection of the Center for Creative Photography, Tucson, Arizona

* *"Hand of Amado Galván,"* 1926 [Plate 7]
Press print, gelatin silver, 23.8 by 18.0
Courtesy of Stephen White Gallery, Los Angeles

Four Pieces of Ancient Tarascan Pottery, 1926
Press print, gelatin silver, 18.0 by 22.5
Courtesy Daniel Wolf, Inc., New York

* *"Hat and Shoes,"* 1926 [Plate 9]
Press print, gelatin silver, 19.0 by 24.0
Collection of the California Museum of Photography, University of California, Riverside: Extended Loan from Hardie C. Setzer

* *Woman Seated on a Petate*, 1926 [Plate 10]
 Press print, gelatin silver, 19.1 by 24.0
 Collection of the Center for Creative Photography, Tucson, Arizona

 Abstract Serpent Head, 1926
 Press print, gelatin silver, 23.0 by 19.0
 Collection of Zohmah Charlot, Honolulu, Hawaii

 "Rose Roland" de Covarrubias in a Tehuana Costume, 1926
 Vintage exhibition print, platinum or palladium, 17.8 by 23.8
 Collection of the Helen Foresman Spencer Museum of Art, Lawrence,
 Kansas

 "Rose Roland" de Covarrubias with Her Eyes Closed, 1926
 Project print, gelatin silver, 16.1 by 24.0
 University Library, Special Collections, University of California, Santa Cruz

* *"Jean Charlot,"* 1926 [Figure 6]
 Vintage exhibition print, gelatin silver, 9.7 by 7.1
 Jean Charlot Collection, Thomas Hale Hamilton Library, University of
 Hawaii at Manoa, Honolulu, Hawaii

 "Dr. Atl," 1926
 Vintage exhibition print, gelatin silver, 23.7 by 18.7
 Collection of the Art Institute of Chicago, Illinois

 "Casa de Vecindad," I, 1926
 Press print, gelatin silver, 18.9 by 24.1
 Collection of the Center for Creative Photography, Tucson, Arizona

* *"Casa de Vecindad," II*, 1926 [Plate 8]
 Press print, gelatin silver, 19.2 by 24.9
 Collection of the Center for Creative Photography, Tucson, Arizona

 "Casa de Vecindad," III, 1926
 Press print, gelatin silver, 18.9 by 24.1
 Collection of the Center for Creative Photography, Tucson, Arizona

"Casa de Vecindad," IV, 1926
Press print, gelatin silver, 19.1 by 24.1
Collection of the Center for Creative Photography, Tucson, Arizona

"Casa de Vecindad," V, 1926
Press print, gelatin silver, 19.2 by 23.9
Collection of the Center for Creative Photography, Tucson, Arizona

Pastel Drawing by Francisco Goitia of a Casa de Vecindad, I, 1926
Press print, gelatin silver, 22.4 by 18.8
Collection of the Center for Creative Photography, Tucson, Arizona

Pastel Drawing by Francisco Goitia of a Casa de Vecindad, II, 1926
Press print, gelatin silver, 18.7 by 18.3
Collection of the Center for Creative Photography, Tucson, Arizona

* Unknown Photographer [Figure 35]
Tina Modotti, Rafael Sala, Edward Weston, Monna Alfau, and Felipe Teixidor in Front of a Maguey Plant, 1926 (?)
Snapshot, gelatin silver, 7.5 by 9.8
Private Collection

* *"Maguey, Texcoco," without Clouds*, 1926 [Figure 34]
Vintage exhibition print, platinum or palladium, 19.0 by 24.3
Collection of Manuel Alvarez Bravo, Mexico City

+ *"Maguey Cactus, Mexico,"* 1926
Modern Print by Cole Weston, gelatin silver, 19.0 by 24.0
Philadelphia Museum of Art: Gift of Richard L. Menschel

Index

Agniel, Marguerite, *dancer*, 31

Alfaro Siqueiros, David (1896–1974), *painter*, 11, 20, 41–42

Alfau, Monna (b. 1899), *wife of Rafael Sala after whose death she married Felipe Teixidor*, 15, 16, *figures 4, 10, 16, 35*

"*Almond Blossoms*," 85

Alva de la Canal, Ramón (b. 1898), *painter*, 16

Antorcha, magazine, 31, *figure 19*

"*Arcos*," 53, *figure 29*

Armco Steel Company, 14, 39, *figure 8*

Arquitecto, magazine, 48

Atl, Dr. *See* Murillo, Gerardo

Azcopotzalco, 15

Aztec Land Gallery, 14, 15, 29, 30–31, 34, 72

Beals, Carleton (1893–1979), *writer*, 17, 19, 23

Bello Collections, Puebla, 49, 53

Best-Maugard, Adolfo (1891–1964), *art educator and painter*, 11, 15, 19

Braniff, Oscar (1875–1968), *businessman*, 30

Braniff, Mrs. Oscar (1898–1972), *also known as Beatriz Cornejo*, 30

Braniff, Tomás, *businessman*, 15, 30

120 *Index* Brehme, Hugo (1884–1954), *German-born photographer who emigrated to Mexico,*
55–56, *figure 31*
Brenner, Anita (1905–74), *writer,* 16, 38, 42, 43, 44, 46, 47, 48, 49, 50, 51,
52, 55, 60, 61, 62, 64, 65, 71, 100, *plate 5*
Brenner Collection, 50, 53
"El Buen Retiro," 13, 14, 22
Bullfighter and Boy, 46

"*Caballito de cuarenta centavos,*" also known as "*Horsie,*" 31, *figure 7*
Café de Nadie, 16
"*Calle de Rayon,*" 46
Calle Lucerna, 14
Calles, Plutarco Elías (1877–1945), *president of Mexico,* 19, 52
Camera, magazine, 3
"*Casa de vecindad,*" 62, *plate 8*
Chandler, Harry (1864–1944), *owner of the* Los Angeles Times, 8
Chapingo, 23
Charlot, Jean (1898–1978), *French artist who emigrated to Mexico and later to the*
U.S., 11, 15, 16, 18, 20, 21, 42, 43, 46, 56, 60, *figure 6*
"*El Charrito,*" 46, 51, *figure 26*
Chupícuaro, 61
Churubusco, 15, 24
"*Circus Tent,*" 31, *plate 3*
"*Clay Fruit,*" 31
clouds, 31, 36, *figure 19*
Colima, 11, 41
Colima, S.S., 5, 11
Colonia Condesa, 31
communism, 18, 83
"*Conceptos del artista,*" 72–73, 92
Constitution of 1917, Mexican, 8, 52
Coolidge, Calvin (1872–1933), *U.S. president,* 8
Covarrubias, Rose Roland de, *dancer and amateur photographer,* 39

Cueto, Germán, *artisan and artist*, 16, 18
Cunningham, Imogen (1883–1976), *photographer*, 38

Dandini, Luisa, 30
Davis, Fred, *proprietor of the Sonora News Co. and art collector*, 53
Daybooks, 11, 15, 31, 42, 53, 55, 61, 73
Detail of Stone Frieze from Mitla, 53
d'Harnoncourt, René (1901–68), *buyer for the Sonora News Co. and later director of the Museum of Modern Art, N.Y.*, 55
Díaz, Porfirio (1830–1915), *president of Mexico*, 21
Doheny, Edward L. (1856–1935), *petroleum magnate*, 8, 38

Ecatepec, 52, 53
Eisenstein, Sergei (1898–1948), *film director*, 71
Enciso, Jorge (1879–1968), *painter*, 10, 21
estridentismo, 16–19, 41
Etla, 52

Fall, Albert B. (1861–1944), *adviser to Pres. Harding*, 8
Fernández Ledesma, Gabriel (b. 1900), *artist and editor*, 72, 73, 89
Film und Foto Exhibition, Stuttgart (1929), 73, 100
Fonserrada, Carmen, *painter*, 61
Forma, *magazine*, 18, 72
"*Form follows function*," 42

Galván, Manuel Hernández. *See* Hernández Galván, Manuel
Galván, Amado, *potter*, 60, *plate 7*
Gamio, Manuel (1883–1960), *anthropologist*, 19
García Icazbalceta, Francisco Monterde, *poet*, 31, 72
Glendale, Calif., 38, 39, 71
Goitia, Francisco (1882–1960), *artist*, 10, 19, 60, 61, 62, 64
Gómez Robelo, Ricardo (c. 1884–1924), *art critic, Precolumbianist, and director of the Department of Fine Arts, Mexico*, 4, 11, 15, 39

González, Xavier, *artist*, 16

Graflex camera, 24, 43, 49, 99, 101

"*The Great White Cloud of Mazatlán*," 14, *plate 1*

Gruening, Ernest (1887–1974), *social scientist and U.S. senator*, 8

Guadalajara, 11, 16, 41, 42, 48, 51, 58, 60, 64

Guanajuato, 60

Guerrero, Elisa (b. 1903[?]), *Xavier Guerrero's sister*, 14, 15, *figure 3*

Guerrero, Xavier (1896–?), *painter*, 11, 14, 20, 39, 43

Guggenheim Foundation, 65

Hagemeyer, Johan (1884–1962), *photographer*, 4, 5, 14, 37, 38, 85

Hernández Galván, Manuel (?–1926), *Mexican senator*, 15, 29, 31, 39, *figures 15, 16*

Hokusai, Katushika (1760–1849), *printmaker*, 13

"*Horsie*," also known as "*Caballito de cuarenta centavos*," 16, 28, *figure 7*

Idols behind Altars, 49, 51

El Informador, *newspaper*, 41

Irradiador, *magazine*, 16, 18, *figure 8*

Jalisco, 47

Janitzio, Island of, 55, 56, *figures 31, 32*

juguetes. *See* toys

Käsebier, Gertrude (1852–1934), *photographer*, 4

Korona camera, 49

Krasnow, Peter (1886–1978), *artist*, 37

Krasnow, Rose, *Peter's wife*, 5

Kuhn, Walt (1877–1949), *artist*, 68

Lawrence, D. H. (1885–1930), *writer*, 29, 89

Leaves of Grass, 65

Lerner, Miriam, *dancer*, 38

List Arzubide, Germán (b. 1900[?]), *writer*, 16, 18

London Salon of Photography, 3

Los Angeles, 26, 36, 37, 74

Los Angeles Times, 8

M., 61

McGehee, Ramiel (c. 1885–c. 1940), *dancer and editor*, 37

"*Maguey, Texcoco*," 62, 100, *figure 34*

Manzanillo, 11, 41

Maples Arce, Manuel (1900[?]–1981), *writer*, 16, 17

Marín de Rivera, Guadalupe (1900[?]–1982), *Diego Rivera's wife*, 15, 29, 31, 39

Martínez Pintao, Manuel, *artist and artisan*, 15

Mather, Margrethe (1885[?]–1952), *photographer and Weston's assistant, 15, 37*

Mazatlán, 7, 11

Mena, Ramón, (1874–1957), *archaeologist*, 15

Méndez, Leopoldo (1902–69), *painter*, 16

Mérida, Carlos (1891–?), *artist*, 10, 16

Mexican Folkways, *magazine*, 44

Mexico City, 11, 42, 54, 55, 60; Academia de Bellas Artes [Fine Arts Academy], 4, 25; Casa de la Marquesa de Uluapa, 61; Cathedral, 24; National Musuem of Archaeology, History, and Ethnology, 61; Palacio de Minería, 34; Preparatoría, 60; Santa Anita, 24; La Santísima, 24; Teatro Nacional, 13, 21

Mexico, National University of, 48, 100

Mexico This Month, *magazine*, 50

Michoacan, 47, 53, 55, 56, 58

Mitla, 53

Modotti, Tina (1896–1942), *Weston's pupil and companion*, 4, 5, 7, 11, 14, 15, 16, 19, 23, 28, 29, 31, 34, 36, 41, 49, 50, 58, 61, 86, 88–89, *frontispiece and figures 1, 10, 16, 20, 35*

Moholy-Nagy, László (1895–1946), *photographer*, 60

Mondragón, Carmen [Nahui Olín], *poet and painter*, 15, 29, 31, *figure 17*

Montenegro, Roberto (1885–c.1975), *painter*, 11, 20, 21

Morelia, 51, 55

Muray, Nikolas (1892–1965), *photographer*, 4

Murillo, Gerardo [Dr. Atl] (1875–1964), *painter, poet, and volcanologist*, 15, 20, 21, 25, 31

New York City, 4, 18

nudes, 36, 38–39, 43, 71, *plate 5, figure 20*

Oaxaca, 42, 47, 48, 51, 54, 55, 68

Obregón, Alvaro (1880–1928), *president of Mexico*, 8, 19, 21; government of, 21

O'Hea, Patrick, *businessman*, 30

O'Higgins, Paul (b. 1904), *painter*, 42

O'Keeffe, Georgia (b. 1887), *painter and Alfred Stieglitz's wife*, 4, 14

Olín, Nahui. *See* Mondragón, Carmen

Orozco, José Clemente (1883–1949), *artist*, 11, 14, 20, 60, 64

Pacheco, Máximo (1907–?), *artist*, 16, 81

Pallares, Alfonso, architect, 48, 51, 54, 64

Partridge, Roi (b. 1888), *printmaker*, 38

Pátzcuaro, 55, 58, 60; Sanctuary of Nuestra Señora de Guadalupe, 58

Photographers' Association of America, 3

Photo Miniature, *magazine*, 4

Picasso, Pablo Ruiz y (1881–1973), *artist*, 13, 25, 81, *figure 2*

picturesque, 24, 55

Pintao. *See* Martínez Pintao, Manuel

"Pirámide del Sol," 31, *figure 18*

Pitcher from Monte Alban, 53

popular art, 11, 21–22, 76. *See also* pulquería paintings, toys

Porter, Katherine Anne (1894–1982), *writer*, 8–10, 11, 17

portraiture, 29–30, 32, 36, 39, 74, 76

project prints, 46, 62, 100

Pruneda, Alfonso, *rector of the National University of Mexico*, 48

Public Works of Art Project of Southern California, 65

Puebla, 48, 49, 52, 53, 54

Pulquería paintings, 13, 25, 42, 44, 46–47, 60, 65, *figures 10, 11, 26, 27*

Querétaro, 60, 62

Quintanilla, Luis (b. 1895[?]–?), *poet*, 18

Ray, Man (1890–1976), *photographer and painter*, 60

"*R.S.—A Portrait*," 85

Revolution, Mexican, 17

Revueltas, Fermín (1903–35), *painter*, 16, 20

Richey, Roubaix de L'Abrie, also known as "Robo" (1890–1922), *Tina
 Modotti's husband, a designer*, 7, 10

Rivera, Diego (1886–1957), *artist*, 11, 14, 15, 16, 18, 19, 20, 22, 23, 25, 29,
 34, 42, 44, 46, 56, 81, 83, *figure 9*

Romero de Terreros y Vinent, Manuel (1880–c.1970), *art historian*, 22

Rouveyre, André (1896–1962), *printmaker*, 34

Sala, Rafael (c. 1895–1927), *painter*, 15, 16, *figures 5, 10, 16, 35*

San Angel, 24

San Antonio, 54

San Francisco, 3, 37, 38

San Augustín Acolman, 24, 62

San Cristóbal, 15

Seligmann, Herbert J., *writer*, 4

Seneca view camera, 49, 88, 98, *frontispiece*

Shaw, Ruth, 18, 85

Sheeler, Charles (1883–1965), *painter and photographer*, 4, 90

Silva, Gustavo P., *photographer*, 31

Sindicato de Pintores, escultores y grabadores méxicanos, 11

Siqueiros David Alfaro. *See* Alfaro Siqueiros, David

"*Smokestacks*," 13, 14, *figure 8*

Solchaga, Salvador, 22

Sonora News Company, 55

Stieglitz, Alfred (1864–1946), *photographer, editor and gallery owner*, 3, 4, 5, 14,
 37

still life, 26, 36, 42, 47, 74, 85. *See also* toys
Strand, Paul (1890–1975), *photographer*, 4

Tacubaya, 13
Teixidor, Felipe (c. 1895–1980), *historian*, 15, 16, *figures 10, 16, 35*
Tenayuca, 15
Tennant, John, *editor*, 4
Teotihuacán, San Juan and the Pyramids at, 15, 19, 32, *figure 18*
Teotilan, 54
Tepotzotlán, 15, 24, *plate 4*
Texcoco, 62, *figure 34*
Thompson, Dody, 100
Tlacolula, 54
Tonalá, 58
Toor, Frances, *editor*, 44
"Torso," 31
toys, 26–29, 32, 37, 38, 42, 43–44, 54, 60, 68, 72, 76, *plate 2, figures 13, 14, 22, 23*
Tropico, 4, 7
Turnbull, Roberto, *filmmaker*, 14

Union of Mexican Painters, Sculptors, and Engravers, 11
United States–Mexican relationships, 7–8
Uruapán, 58

Vasconcelos, José (1882–1959), *philosopher and educator*, 19–20, 31
Vestal, David, *writer*, 49

Wanamaker exhibitions, Philadelphia, 3
Weston, Cole (b. 1919), *Weston's fourth son*, 28, 100, 101
Weston, Edward Chandler (b. 1910), *Weston's first son*, 5, 11, 13, 14, 37
Weston, Flora Chandler, *Weston's first wife*, 5, 25
Weston, Lawrence Neil (b. 1914), *Weston's third son*, 28, 31, 38

Weston, Theodore Brett (b. 1911), *Weston's second son*, 39, 41, 49, 50, 58, 60,
61, 100, 101
White, Clarence (1871–1925), *photographer*, 4
Wilton, Ruth, 31
Wolfe, Bertram (1896–1977), *social scientist*, 83
Wright, Harry, *businessman*, 30

Xochimilco, 56, 61

Zuloaga y Zabaleta, Ignacio (1870–1945), *painter*, 30
Zuno, José Guadalupe (1891–1980), *governor of Jalisco, artist, and art patron*, 41,
58
Zwaska, Caesar, *photographer*, 60

Design: Barbara Jellow

Typography: G & S Typesetters, Inc., Austin, Texas
Printing/Binding: Halliday Lithograph Corp., West Hanover, Massachusetts